MICHAEL FREEMAN
BLACK & WHITE
PHOTOGRAPHY
FIELD GUIDE

The **essential guide** to the art of creating black & white images

Focal Press
Taylor & Francis Group

NEW YORK AND LONDON

First published in the USA 2013 by Focal Press

Focal Press is an imprint of Taylor & Francis Group
an informa business
70 Blanchard Road, Suite 402, Burlington, MA 01803, USA

This book was conceived, designed, and produced by Ilex
Press Limited, 210 High Street, Lewes, BN7 2NS, UK

Publisher: Alastair Campbell
Creative Director: Peter Bridgewater
Associate Publisher: Adam Juniper
Managing Editor: Natalia Price-Cabrera
Specialist Editor: Frank Gallaugher
Editor: Tara Gallagher
Editorial Assistant: Rachel Silverlight
Creative Director: James Hollywell
Designer: Jon Allan
Color Origination: Ivy Press Reprographics

Library of Congress Cataloging in Publication Data:

A catalog record for this book is available from the
Library of Congress.

ISBN: 978-0-415833-51-6 (pbk)
ISBN: 978-0-203486-76-4 (ebk)

Typeset in Aptifer Sans LT Pro

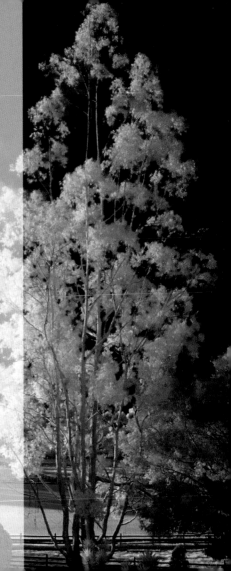

CONTENTS

INTRODUCTION

Black-and-white photography occupies a unique place in the world of art and imaging, all the more surprising because within the world of photography it is taken so much for granted. What I will attempt in this book is to jolt black and white out of its normally complacent position, and in this I'm helped by the completely changed circumstances of digital photography.

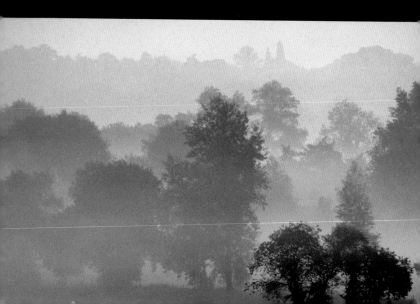

Why complacent? Because black and white has become so established as the senior tradition of photography over the course of more than a century that its reasons for being are only rarely questioned.

For many people, perhaps most, black-and-white photography just "is." I just re-read a volume on the history of photography by Ian Jeffrey, titled *Photography: A Concise History* that appeared in Thames & Hudson's *World of Art* series, where black and white is so much assumed to be center stage that color fills just three pages out of 240. This is by no means unusual, but it is hard to justify simply on the grounds that there were more years spent in black and white than in color. It also won't do for the modern world of digital photography, in which the choice of one or the other is in the face of every photographer each time they decide to process on the computer.

It seems that most photographers, when they are shooting or processing, inhabit a world of photography alone, and only a few see their work in the wider context of art. I have to say "seems" because there is no way of quantifying this, but what is not in doubt is this: In the entire body of writing and discussion on photography, references to painting or any other graphic art are very thin on the ground. This is a little strange, not to say short-sighted, but it's part of the reality of our photographic world. There are historical reasons for this, as there are, well, philosophical reasons.

From the other side of the fence—the unconstrained art side—there has been more acceptance of photography. A fairly recent phenomenon, which tends to set many photographers' teeth on edge, is the appropriation of photography by artists who do not claim to be primarily photographers. In other words, contemporary artists invade photography more than photography invades art.

And it is this unmistakable sense of photography being its own world, very largely self-contained, that allows us to be complacent about black and white. It's just something that photography grew up with. Now, however, things are on the move, which is what I want to explore in this book.

THE BLACK & WHITE TRADITION

Digital photography has very clearly changed the way we can shoot in black and white, and it is perfectly obvious that by far the most important practical difference between a sensor and film is that now you can have both color and monochrome from the same shot. There is no prior choice to be made, no decision to load black-and-white film rather than color film before setting out.

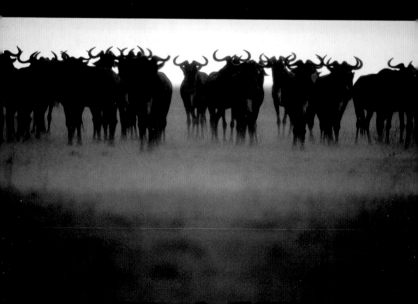

As a result, most of what is written and discussed about digital black and white focuses on the practicalities— how to convert, how to adjust channels in order to alter the brightness of different colors as they appear in grayscale, how to achieve the "look" and grain of a favored black-and-white emulsion, and so on.

All are essential and valuable topics to study, but they skip two key issues: More fundamental than the "how" of shooting monochrome is "why" and "when." There's nothing too complicated about explaining how to achieve all the various kinds of monochrome effect from a digital image— and I hasten to add that this is all included in this book—but what is much more interesting is the choice to make the image in black and white rather than in the more obvious color.

This choice transcends the difference between sensors and film, and it draws us into the long and rich tradition of black-and-white photography. Film and earlier processes, of course, weigh heavily on this tradition, and for this reason I make no apology for looking at the past. Black-and-white film photography, its image qualities and processes, have a great deal to teach us. Not only this, but black-and-white photography is traditionally more strongly associated with art than color photography, and there are also lessons to learn from monochrome painting. The common theme running through all of this is restricting the palette. What sets black and white apart from color is that it is not the way we see the world, and it does not pretend to represent reality. It is a translation of a view into a special medium with very particular characteristics. As we will see, there has been a changing perception of black and white as a medium in photography. Crudely put, it began as necessity, then became accepted as normal, and now, with the full choice of color (and any kind of color) coupled with the infinite processing possibilities of digital images, it is a creative choice.

Monochrome in Fine Art

Monochrome—black and white even more—occupies the same minority position in the history of art as color did in photography's first hundred years.

The reasons for this complete reversal of status bear some examination, because they help us to understand the independent way in which photography has developed. Independent of the rest of art, that is. Monochrome in photography is used more or less interchangeably with black and white, but not quite so in the wider world of art. Monochrome painting is largely a twentieth-century phenomenon, whereas the history of black and white is mainly that of ink, one of the most ancient of media.

The most common source of ink has always been carbon, held together by binding agents, and in the earliest times it can have been only a short step from touching the lamp black or soot over a fire to painting and drawing. The use of black ink in art was universal because of this ease of production. Ink appeared in China at least 5,000 years ago and in India at least 6,000 years ago. Other sources included ferrous sulfate, tannins from gallnuts, cuttlefish, and hawthorn bark.

Its main uses in Western art have been for drawing and for indirect application, such as etching and woodcuts. In East Asia, directly applied by brush in the form of calligraphy and scroll paintings, ink enjoyed a higher status. There, laid down in broad strokes with brushes, its qualities in covering an area of paper were more critically acknowledged. The immediate commitment needed with brush strokes

proved to be a fertile ground for developing great skill, and for a finely tuned aesthetic appreciation.

Monochrome painting in the West, known as "grisailles" (from the French *gris*, meaning "gray"), is known from the Renaissance onwards, but occasionally rather than often, and a typical use was in frescoes in shades of gray and/or brown. Its use was often dictated by a need to execute quickly and cheaply more than for aesthetic reasons. It was the rise of abstract art in the twentieth century that led to more experimentation with painting in a single color, and this color was not confined to black or white. The Suprematist painter Kasimir Malevich produced black on white, and white on white paintings from 1913; Ben Nicholson produced all-white low reliefs in the 1930s; Yves Klein created a series of paintings in blue in the 1950s; Agnes Martin in black, white, and brown in the 1960s; Mark Rothko's late paintings from the 1960s; also the contemporary Chuck Close in black and white; and the Chinese contemporary artist Shao Fan in black on black, among others.

The connection between monochrome painting and monochrome photography is notably absent from discussions of art history, but it seems to me a fruitful area, especially now that digital capture makes it a free choice for photographers. The reasons why painters choose to work with a severely restricted palette may not be very different from the preferences of photographers in black and white. In the twentieth-century West, monochrome was

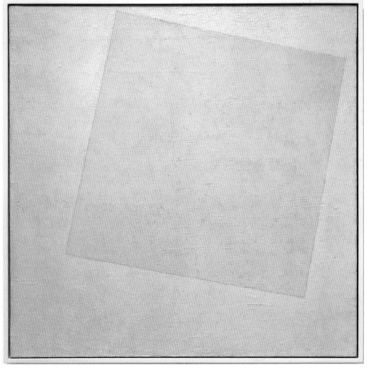

frequently tied to simplicity of form, particularly in a geometric sense. The short-lived Russian Suprematist movement (not at all to be confused with supremacism) set the scene for this, with Kasimir Malevich's squares and circles in black and in white, and it can be seen later in Ben Nicholson's white works and in Agnes Martin's hand-drawn grids. Some hint of the emotional significance of monochrome

KAZIMIR MALEVICH

One of Malevich's paintings, "Supremist Composition: White on White, 1918," in which he sought to express "the supremacy of pure feeling or perception in the pictorial arts."

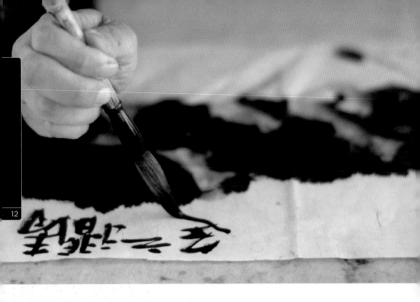

comes through in Malevich's writing when describing his Black Square, 1913: "I felt only night within me and it was then that I conceived the new art, which I called Suprematism." This emotion-through-monochrome is a recurring theme in photography, as can be seen in the enduring work of, among others, Don McCullin, Bill Brandt, and Harry Callahan.

The American painter Agnes Martin moved in the early 1960s from early experiments with bands of bright color to a severely muted palette, coinciding with a trend in American art at the time toward reductivism—using a few elements only, in color, tone, and form, to avoid illusion and representation. She dated her attaining artistic maturity to this time, saying: "I finally got to an absolute abstract painting." Significantly, Martin was interested in Chinese art, art philosophy,

CHINESE CALLIGRAPHY

The above image shows contemporary Chinese artist who works principally in brush and ink. The modulations of a single color—black—through skillful handling of the heavily loaded brush initiated a strong Asian tradition of black and white.

ALTERNATIVE LIGHT

A number of different treatments of black subjects indicate the potential range of even a narrow palette when interpreted through exposure choices.

and Taoism; and from this, in the importance of communicating absence. One of her statements reads, "Two late Tang dishes, one with a flower image, one empty. The empty form goes all the way to heaven." The monochrome feature of Martin's work is just one of the methods she employed to simplify in order to make a spiritual connection, as the statement alludes to. She defined art as "the concrete representation of our most subtle feelings," and subtlety of color and tone were very evidently a key method in this exploration.

Better known, abstract expressionist Mark Rothko also moved through his painting career from colorful toward a restricted palette, and his last paintings were in near black and near gray. His *Black-Form* paintings in particular, never shown together during his lifetime, appear at first glance as solid black, but reveal a slow build-up of layering and very fine gradation. This has the effect of drawing the viewer into a separate world with its

WHITE ART

Imprint is a white-on-white piece by Yukako Shibata, in which a high key is explored. The physical indentations are given an illusory quality by having shadows painted into them.

own range of luminosity. As with some of the low-key photography we will see later in the book, once the viewer accepts the very different range of tone from the surrounding world, the perception of fine shading and minute tonal differences is heightened.

A contemporary Chinese artist following this route is Shao Fan. His work, like that of the literati in earlier centuries, is broad ranging, from sculpture to calligraphy, to architecture, garden design, and painting—a very Chinese approach to the arts. In his black series, dating from 1998, Shao Fan works in oil on canvas in a tonal range that rarely rises above dark gray. He writes, "The low key and very weak contrast create an atmosphere of the

MONOCHROME

As in photography, monochrome can mean a color other than black. In this piece by Yukako Shibata, a specific blue casts a reflection on the white surface, yet is unseen as it is painted on the inside of the frame.

supernatural. It renews our attention to the insignificant, and to things in the process of disappearing, a simultaneous feeling of distance and attraction." Subtle differences in color, akin to what traditional black-and-white photographers think of as toning, play an important part.

Another contemporary artist, whose work conflates painting and sculpture, and who is drawn to the subtle and low-chromaticity end of the scale, is London-based Yukako Shibata. For her, monochrome means working within one specific hue, often modulating it by means of reflection from close external surfaces, such as a white wall. She explores low chromaticity in her work and a major inspiration is what Shibata calls "the

fugitive colors of nature." Delicacy, very fine transitions of hue, and a sense of calm rather than stridency mark her interests. Painters, of course, can choose to see and interpret with complete freedom, but now digital processing gives photographers the same opportunities, and restricting the color range definitely encourages a contemplative approach to imagery.

As we will see time and again in photography, restricting the palette allows the artist to concentrate fully on the subtleties of tone. As any calligrapher knows, the quality of black is infinitely variable, and goes far beyond any simple numerical measurement of darkness. The ways in which black varies as the brush is lifted slightly on the paper during a stroke find their equivalent in delicate tonal adjustments during the processing of a black-and-white photograph.

The Photographic Tradition

The technical history of photography actually forced monochrome on us in the most obvious way. Quite simply, light-sensitive materials that could be used to capture an image on a flat surface reacted to light in total, undivided by wavelength.

Recording the color of a scene meant filtering the light through a set of at least three colored transparent filters, and that involved a much more complicated feat of technology than simple monochrome.

Even so, it might come as a surprise to many people to learn that the first permanent color photograph, taken by James Clerk Maxwell, was as early as 1861.

Various processes were invented between that date and the 1930s, but technical limitations prevented their mass use, and it was not until the Eastman Kodak Company introduced the integral tri-pack color film in 1935 that black and white had any realistic competition as a medium. This was the classic Kodachrome.

The earliest photograph, taken by Nicéphore Niépce in 1826, used a substance that hardened rather than darkened when exposed to light— a type of asphalt that was already used in engraving. Coated on a pewter plate, the asphalt was exposed to a view from Niépce's window. After about eight hours,

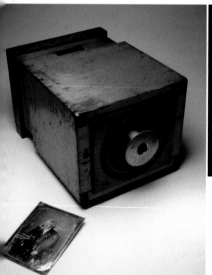
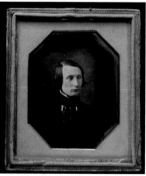

DAGUERREOTYPE
These images show a simple daguerreotype camera in wood, with a focusing mechanism in which the rear plate holder is racked out backwards. Accompanying it, a daguerreotype portrait of Cyrus West Field, the American who laid the first transatlantic telegraph cable.

be viewed at a particular angle and, being a positive, could not be used to make a quantity of prints. Nevertheless, the exposure time had been reduced from eight hours to between 20 and 30 minutes, and although this was still too long for portraiture, which had to wait for later improvements, photography had finally become a practical possibility.

The daguerreotype was soon challenged by an alternative process, the calotype, which used paper instead of a metal plate, and was closer to modern films in that it produced a negative image that could be used to make as many positive prints as the photographer wanted. The reproductive capacity made this process an important rival to the daguerreotype, despite the poorer quality of the image. The inventor was the Englishman William Henry Fox Talbot (1800–1877) who, starting with a high-quality writing paper, added coatings of silver nitrate and potassium iodide, followed by a solution of gallic acid and silver nitrate to sensitize the paper. Having made the exposure, the paper was developed in a second application of the gallic acid/silver nitrate solution. Once dry, the paper negative was ready for making contact prints.

The next important step in the progress of emulsion was the invention of the collodion process by Frederick Scott Archer (1813–1857) in 1851. Also known as

the asphalt exposed to the bright parts of the scene was so hardened that it resisted the solvent that Niépce then poured over it; the unexposed, dark parts washed away.

Within twelve years, Niépce's partner, Louis Daguerre, had discovered a more sensitive photographic plate. Copper, already coated with silver, was sensitized by exposure to iodine vapor rising from heated iodine crystals. After the picture had been taken, the image, not yet visible, was developed by mercury vapor—a dangerous process with health hazards not fully appreciated at the time. The image was finally fixed with hyposulphite of soda, and the result was a finely detailed, delicate photograph. However, because of its mirror-like finish, it had to

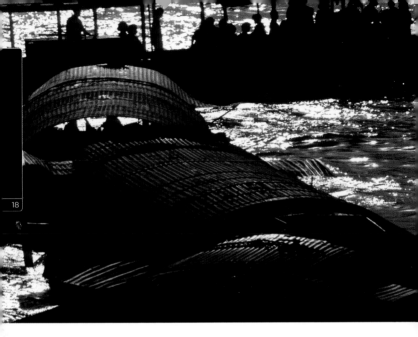

the wet-plate process, the collodion process quickly replaced other systems because despite the great inconvenience of preparing the plates—which had to be carried out on the spot just before taking the picture—it allowed exposures of as little as ten seconds. To achieve this great sensitivity, the photographer had to pour collodion, a solution containing potassium iodide, onto a glass plate, tilt it in different directions until the coating was even, and then quickly dip the plate in a silver nitrate solution. Because the sensitivity was largely lost when the collodion dried, the plate had to be exposed wet, making life very difficult for the photographer on location.

SILHOUETTE AND FLARE

The limited response of film and sensors to the full dynamic range of sunlit scenes has become accepted as a photographic characteristic—objects in silhouette, and glittering flare from highlights, for example.

By the 1870s, an emulsion made up of gelatin and silver bromide had been invented as a dry substitute for collodion, and soon plates were being mass-produced. Although glass (which is bulky and easily broken) has now been replaced by flexible film, black-and-white emulsion remains basically the same: the light-sensitive crystals, known as grains, are embedded in a layer of gelatin. Film was

WHITE SKY VS TONEMAPPED
This is a modern photograph, but processed in two ways: as blue-sensitive, demonstrating the sensitivity of early emulsions, and as a tone-mapped HDR image, from five exposures, to reveal all tones from the original scene.

Digital Monochrome

Creative Choices

originally made of celluloid, but has since moved through nitro-cellulose to cellulose acetate to the immensely stable synthetic polymers of today. Whatever its composition, the use of film made it possible to roll up long strips of emulsion, the basis of motion picture film, 35mm film, and roll film.

The precise sequence of events that follows the exposure of film to light is complex. In the first step, light releases photoelectrons, and these combine with silver ions to produce silver atoms, which form around small specks of impurity scattered throughout each silver halide crystal. At this stage, there is still no visible image on the film, and it takes a chemical developer to produce it. Development blackens the parts of the emulsion that were exposed to light, by reducing the grains of silver halide to metallic silver, which is dark. Each grain is either developed—that is, blackened—or not; there are no halfway stages of gray. The final result, with a range of tones in the negative, is due to the number of developed grains in any small part of the film: if only a few have been developed, scattered among many undeveloped ones, the tone will be a light gray, but if all have reacted, then the film will be black.

Wavelength & Sensitivity

In normal color photography, one of the basic aims is to record the scene as it looks to the eye.

This may sound too obvious to mention, and most camera sensors and lenses achieve results so perfectly acceptable that we rarely question it, but things become interesting in this area when you shoot for monochrome. At heart, this is a technical issue involving wavelength.

Our eyes are sensitive to a very small part of the electromagnetic spectrum, from around 400nm to 700nm—what is called, obviously, the visible spectrum. In reasonably good light, the eye can distinguish millions of colors. It manages this because the cones are divided into three types: those sensitive to red, others to green, and others to blue. These three together embrace more or less the full spectrum, so that by varying the input from each, any other color can be made. In the case of our vision, this occurs in the brain, but the three kinds of receptor are not equally efficient. The eye is most sensitive to yellow-green, and least sensitive to blue; what we cannot see is ultraviolet, the reason being that the eye has two yellow filters, over the lens and over the fovea, which probably evolved to reduce chromatic aberration, at its greatest in violet and ultraviolet light.

Camera sensors do not match the eye's color response, and need both physical filters and special image processing to come close. Sensors, indeed, record monochrome, and the means for capturing color in the vast majority is a filter in front, called a Bayer array. This is a mosaic of red, green, and blue, each square of color sited over on photosite on the sensor. To correspond more closely with the human eye's extra sensitivity to green light, there are twice as many green filters in a Bayer array than there are red or blue. The human eye's peak sensitivity is in yellow-green at 555nm; it reacts very poorly, by contrast, to wavelengths shorter than violet and longer than red. Sensors also differ from the human vision system in that they are sensitive to infrared. As a result, normal cameras have sensors with an infrared-cut filter (as we'll see on page 82, removing this is the way to customize a camera for infrared photography).

In our experience of colors, some hues are brighter than others: an average yellow, for example, is brighter to us than an average blue. If the tones in which different colors are reproduced in a black-and-white photograph approximate to this experience, the image seems realistic. The blue sensitivity of black-and-white film can result in clear skies that look too pale, but a yellow filter—which absorbs blue—restores the expected appearance.

The principle is straightforward. A colored filter placed in front of the lens will pass more of its own color and block the light of other colors. The contrast between a red tomato and green lettuce leaves in a salad, for example, is clear and obvious when viewed in color, but not at all in black and white.

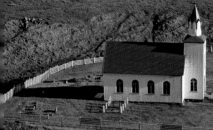

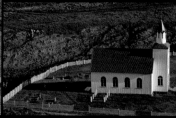

ORIGINAL

DESATURATED
Straight desaturation, equal for all channels.

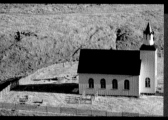

LOW RED
Lowering red and raising green is still high contrast, but opposite to "High Red."

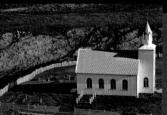

HIGH RED
High red and lower greens create high contrast with a light roof and dark surroundings.

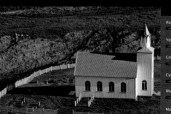

LIGHT RED
A more naturalistic result keeps the red roof light (on the principle that warm colors are thought of as lighter), and the grass medium dark.

Black & White as Normality

A black-and-white photograph is clearly some distance from actually representing a scene.

Until color film became practical and widely available, the very lack of color information was a definite drawback for many photographers and for publications that used photographs. And yet, by about the 1930s, in documentary photography (led by news), black and white had become thoroughly accepted as a normal representation of events and the world in general. From the perspective of now, with color photography long established as the default, this may not be easy to appreciate fully, but in, say, *Life* magazine's and *Picture Post*'s coverage of the Second World War, the veracity of monochrome was unquestioned, and the reading public managed without thinking to bridge the gap between the colored real world and the completely unsaturated image. Black-and-white imagery remained "normal" in newsprint until offset color became practical for dailies around the 1980s. How and why this happened is worth considering, because the decades of black-and-white "normality" impressed the monochrome image with a particular strength and legitimacy.

The onset of acceptance was slow and uneven, and can be argued to have been a special feature of documentary photography, where the aim was to show things "as they are," even though this is a loose concept open to various interpretations. Naturally, documentary photographers, always more concerned with the events in front of them than a

LIFE MAGAZINE COVERS

For many years, *Life* magazine presented a striking combination of a red masthead set against a strong black-and-white picture depicting current events. During the 1950s, color became more usual.

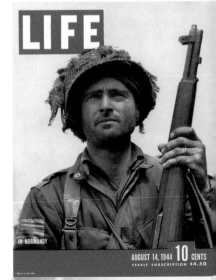

IN NORMANDY

AUGUST 14, 1944 **10** CENTS
YEARLY SUBSCRIPTION $4.50

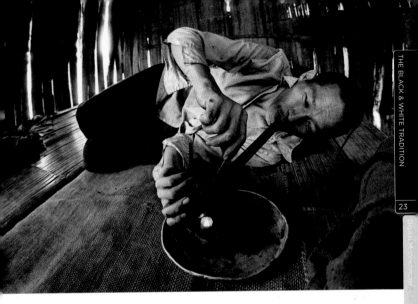

FAST FILM

A 35mm camera and ISO 400 Tri-X film came to embody reportage photography—rapid shooting of subjects in available light—here, an opium addict in northern Thailand.

creative or deliberate treatment of them, worked with whatever was available to them. Speed was a never-ending concern—the ability to capture movement in as many lighting conditions as possible. Even with fast lenses, documentary photography has relied on fast—more sensitive—recording media. This alone kept color at bay, as it was always easier to manufacture faster black-and-white emulsions than color emulsions. Kodak's Tri-X, with its nominal speed of ISO 400, and its ability to be "pushed" later in development considerably higher, became the most popular and widely used of all reportage films.

The period from the 1930s through the 1940s saw substantial technical progress in photography, from cameras to lenses to film. 35mm film, already used in cinematography, became the medium of choice after Oskar Barnack invented the Leica to use it. Loading, winding on, and unloading were faster, and as a result of this and other developments, reportage photography became ever more flexible and adaptable to changing situations. At the same time, this was a socially and economically disastrous period for much of the world, and photography concentrated on these topics more than ever before. Ian Jeffrey, writing in *Photography: A Concise History*

(part of the Thames & Hudson *World of Art* series), took the view that "…during the 1930s, photography's tasks were mainly social and reformist, for which urgent black and white was an apt medium." This is an exaggeratedly narrow view of 1930s photography en masse, and for its own convenience ignores a large area of news journalism, but the point is valid within its frame of reference. Sally Eauclaire, setting the scene for a discussion of how color photography became critically acceptable in the 1970s, wrote in *The New Color Photography*, "Black-and-white photography figures so predominantly in the documentary tradition that we might be conditioned to expect the news in tones, not chromes."

The legacy of this period, approximately from the 1930s through the early 1960s, is that even today black and white is accorded a respect for its documentary "correctness." So much so that in 1997, Graham Clarke, writing in *The Photograph*, part of the *Oxford History of Art* series, could say, "The traditional canon of photography largely eschews color, so that we are faced with the paradox of photography's 'realism' being communicated in black and white… The most obvious aspect of this remains the traditional 'documentary' image, where the presence of color actually lessens the sense of the photograph's veracity as an image and witness. We equate black-and-white photographs with 'realism' and the authentic." Contemporary documentary photographers who stick to black and white as much as possible include Sebastião Salgado, Chien-Chi Chang, and Richard Kalvar, among many others. Some photographers are certainly influenced in this by their preference for the medium of film, but Salgado, for example, has recently moved to digital after extensive testing, and is delighted with it. The medium for him is monochrome rather than film.

Other forms of photography spurred the creation of different strategies. In the studio, for example, the best photographers quickly sidestepped the issue of lack of color and exploited black and white's essential qualitie: lighting, composing for drama, geometry, texture, or sensuousness, according to skill and

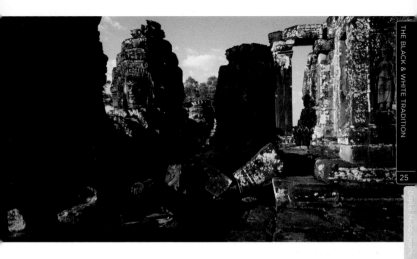

BAYON TERRACE

The upper terrace of the Bayon Temple in Angkor Thom. The colors in the scene are relatively insignificant, and shooting in black and white enables full attention to be paid to the modeling and the massing of shadows and highlights.

taste. From as early as the beginning of the 1930s, Horst P. Horst's Hollywood portraits and fashion shots, for example, are masterpieces of constructed lighting from which color would only have distracted. Portrait photography outside the studio could also make full use of black and white's strengths. Bill Brandt's bold use of dark and light masses, as in his portrait of playwright Harold Pinter on page 157, was another, more spontaneous approach.

And of course, with a full knowledge of the physics of light and the chemistry of reproduction, it was possible for a thoughtful photographer to justify the superiority of monochrome on philosophical grounds. Henri Cartier-Bresson wrote, "Color in photography is founded on a basic prism; for the time being, it cannot be otherwise, because we do not yet have the chemical processes that permit the complex breaking down and reconstitution of color (in the pastel range, for example, the gamut of greens is made up of 375 nuances!)." He went on to argue from this that, "For me, color is a very important medium of information, but it is very limited on the reproduction surface, which remains chemical and not transcendental, not intuitive, as it is in painting. As opposed to black, which has the most complex range, color, on the contrary, offers only a fragmentary range."

Paul Strand made a similar point in his objections to color: "It's a dye. It has no body or texture or density, as paint does [...] So far, it doesn't do anything but add an uncomfortable element to a medium that's hard enough to control anyway." This probably exposes his real concern. One of black-and-white photography's great joys and strengths is that it offers a different world from the one we experience, with less going on in it and therefore more to explore in the image qualities that it does offer. As in most human activity, the simpler the situation, the more effort can be put into what remains. In photography, then, restrict the medium and you increase the potential refinement, meaning that if you are faced with a scale of gray as opposed to a scale of color plus gray shades (as in the illustrations here) you pay much more attention to the subtleties of the gray scale. Strand, by the way, continued to refer to color photography as black and white that had been dyed.

ATTENTION SEEKING

A demonstration of Paul Strand's assertion that "you pay much more attention to the subtleties of the gray scale" in a monochrome image. The color version of this view of the Bank of England is dominated by the sky and the need to hold the highlights, while a black-and-white rendering allows much more attention to be paid to the just-perceptible fluting of the columns.

Deeper than this was an understandable streak of conservatism that ran through many of the established photographers in the 1960s, the time that color was becoming a major force in photography. This conservatism was created because they had spent a lifetime, or part of it, mastering a medium that involved conceptualizing in black and white. It was not that there was much evidence or fear of losing the game, but rather that their black-and-white photography was more intellectual, crafted, and dependent on a hard-won sensibility to how a raw scene from the world could be turned into a very different and specific art

VULGARITY

Intentional vulgarity, as Edward Weston claimed, was seen by some as the legitimate use of color in its early days.

form. There was a distinct feeling at the higher end of photography until well into the 1980s that basically anyone could take a color image, because it simply reproduced what was there; but to make the shift to a unique medium was, simply, a higher calling. Hence the often pompous statements that were frequently made. Walker Evans made the not-very-clever adaptation of Lord Acton's "Power tends to corrupt…" as "Color tends to corrupt photography and absolute color corrupts absolutely… There are four simple words for the matter which must be whispered: color photography is vulgar."

There is a definite sense in reading all these opinions from the 1970s and earlier of a rearguard action being fought to

preserve black and white. It was clear to anyone who thought about it that photography was becoming simpler, available to all, and color photography was going to have its way in the mass market because it was simply what most people wanted. In the end, they need not have bothered so much. Yes, color did take over the world of photography, and even, from the 1980s onward, achieved artistic respectability at photography's more refined end. But far from spelling the demise of black and white, it created a reason among many photographers for wanting a different medium, more refined, and apart from the mass of snapshooters.

The argument hinges on color offering too much. The more that you can expect to capture in an image, the more difficult it is to put your personal stamp on the image and say "this is the way I see it, not the way it is." This was, and is, a genuine concern. A wider choice of materials, more and better tools, are a mixed blessing for

ROADSIDE STAND NEAR BIRMINGHAM, 1936
Walker Evans

any photographer or artist. On the one hand, they make it possible to do new things and explore kinds of imagery that no one tried until now. At the same time, however, they can offer too much choice and distract. It usually helps to have a clear view when you create an image, and cluttering this up with more and more possibilities can just be a damaging nuisance. Cartier-Bresson, one of whose greatest skills was organizing the chaos of fleeting street scenes into compositional unity, said simply, "Imagine having to think about color on top of all this." It's easy to draw parallels with other camera-or-medium inventions. Zoom lenses, now standard, were not thought of as a universal blessing when they began to appear in the late 1950s. Quite apart from optical quality in the early zoom designs (a top-quality prime lens still sets the highest standard), they gave a new dimension to composition. Framing could be fine-tuned infinitely; hugely useful if you are a sports or event photographer shooting from a restricted, fixed position, but for many photographers it just gives an extra layer of choice, meaning more to think about, which can at times delay the shot by just enough to lose it.

And it goes much further than "how can we cope with all of this sensory input." Art can be many things, but it is never about reproducing reality as perfectly as possible. There is always a translation of one kind or another—filtering the real through a creative imagination, if you like. It's tempting to argue that the new digital ways in which color can be manipulated and corrected have actually furthered the cause of black and white. The division between monochrome and color has certainly disappeared with the easy ability to choose exactly how saturated or unsaturated any hue should be in an image. In that sense, black and white simply represents one end of a continuum, not on its own island. Later, in Chapter 4, we'll be treating these shades of tone from the point of view of adding hints of color to monochrome, but the same results could equally be explored in a book on color photography as ways of muting color.

Some of the most interesting photographers for me in relation to all of this are those who switched and still maintained success, at least in their own eyes. Among the older and traditional are Eliot Porter, Harry Callahan, and Joel Meyerowitz, each of whom switched to color while maintaining full respect and affection for black and white. And, if you accept black and white as normality, you could turn the question on its head and ask when and where it would be better to shoot color. This is a rather old-fashioned way of thinking, harking back to the days when color was emerging rather than dominating, but it brings a useful

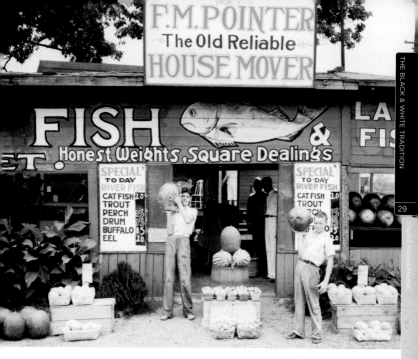

perspective to the same issue of choice. Edward Weston, earlier being both aloof and grumpy about color's "vulgarity" (he had conceded that "when the point of a picture subject is precisely the vulgarity… then only color film can be used validly"), finally became fascinated with the instant colors of Polaroid. He reached the not altogether surprising conclusion that "those of us who began photographing in monochrome spent years trying to avoid subject matter exciting because of its color; in this new medium, we must now seek subject matter because of its color. We must see color as form, avoiding subjects which are only 'colored' black and whites."

In many ways, I think I most like Robert Frank's existential argument for monochrome: "Black and white are the colors of photography. To me they symbolize the alternatives of hope and despair to which mankind is subjected."

Monochrome in Photography vs Painting

We began by looking at painters' experience of black and white in order to put photography in the wider context of the graphic arts.

The most significant difference between painting and photography is that painters have a full choice, and the decision to desaturate the palette has always been taken deliberately, whereas for the first century of photography, black and white was an imposed medium. Of necessity, photographers learned to work within the restrictions of monochrome, and not surprisingly these soon ceased to be thought of as restrictions. For example, the early emulsions were sensitive principally to blue light, and in landscape photography this meant a negative properly exposed for the ground was invariably overexposed for the sky. Good photographers learned to compose the frame to allow for blank white skies—take Timothy O'Sullivan for example.

Another important difference between monochrome in painting and monochrome in photography is the matter of degree of color. In traditional photography, there was a clear distinction between the two because the emulsions were different and quite distinctive (of course, the situation has changed now with digital, as we will see in Chapter 2; but the influence of photography's traditions remains strong artistically). You could do one or the other, not a version in between. No film manufacturer made "half-colorful" film. In painting, however, there has always been a wide choice of pigment, and with the exception of ink-based art, as in China, Korea, and Japan, moving toward

monochrome meant a degree of desaturation of hue that the artist could decide on the spot. In paint, there is a continuum from color to monochrome, not a binary switch, and this perhaps accounts for the relative lack of discussion by monochrome artists on this subject (Agnes Martin, for example, spoke much more about the geometry of her work than about the lack of color).

Now, digital processing offers exactly this continuum of colorfulness, so that black-and-white photography has extensions into subtlety of color rather than simply all or nothing. Any degree of saturation is easily possible, and this brings photography closer to painting in one aspect. Being relatively new, it remains to be fully explored.

BLACK CANYON

Top right: Timothy O'Sullivan, 1871. This shot was originally commissioned by Lieutenant George Wheeler as part of a military survey mission, and has the full title "Black Canyon, From Camp 8, Looking Above."

HALF-COLORED IMAGE

Right: Digital processing makes possible the range of "colorfulness" that was formerly the preserve of painting. This interior view has been deliberately desaturated in parts.

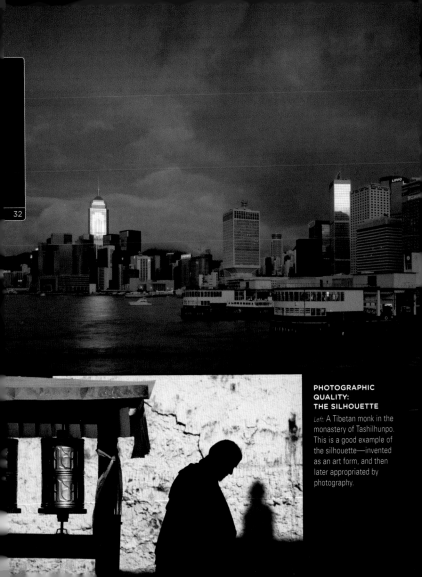

PHOTOGRAPHIC QUALITY: THE SILHOUETTE

Left: A Tibetan monk in the monastery of Tashilhunpo. This is a good example of the silhouette—invented as an art form, and then later appropriated by photography.

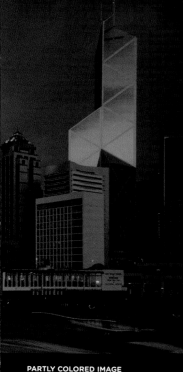

PARTLY COLORED IMAGE

Another possibility from digital photography, which was formerly complicated with film, is to desaturate certain areas of an image, while enhancing the saturation of others.

PHOTOGRAPHIC QUALITY: FLARE

Above: Flare is an optical effect completely characteristic of photography, but not of painting (other than painting that aims to mimic photography).

The Photographer's Choice

Viewed from the perspective of the first half of the twentieth century, it seems completely reasonable that photographers would think of black and white as normal.

Color in its earliest forms, such as Autochrome, and then the revolutionary Kodachrome, was understandably considered exotic, even threatening. But once color chemistry had matured, it was inevitable that it would take over photography almost completely.

The gradual change in the status of black-and-white photography came about as much because of how images are used and distributed as by the possibility of shooting in color. Until very recently, when photography has become fully democratic and open to almost everyone, professional and commercial needs were very influential. It was magazines in particular that were for so long the means for displaying photography to a mass audience. This began in the 1930s, and lasted for at least sixty years, gradually declining in importance in the face of first television and now the internet. Color sold magazines, and the famous weeklies like *Life*, *Stern*, and *Paris Match* moved quickly toward it, while monthlies like *National Geographic* and *GEO* focused all their attention on displaying the best, most exciting, and well-printed color imagery that they could find. This pushed editorial photographers to shift to color. Advertising, which filled pages on the same presses, followed immediately. Moreover, color offset printing processes

became better and better, and also cheaper. As recently as the 1980s, it was entirely normal for a heavily illustrated book to mix black and white with color just for cost reasons. A signature (typically 16 pages) of color images would frequently be followed by one of black and white. Color printing is now so efficient that today this is virtually unthinkable.

Many photographers simply moved to color and enjoyed what it had to offer. Others, as we saw, fought rearguard actions. Some simply accepted the new demands from publishers by making as few changes as possible to the way they worked. Ian Berry, a Magnum photographer, told me, "I just shoot in color as if I were using black and white [which he preferred]." For a long while, many of the avenues for displaying black-and-white photography closed off. Just the gallery print remained, which of course focused energies on print quality in a way that color has hardly ever received.

But finally, the sheer universal availability of color, and the excesses it has been put to in richness, vibrancy, and super-saturation, have given black and white a status of refinement. The "excesses" began with the efforts of film manufacturers to satisfy their mass markets, the Japanese manufacturer Fuji being particularly active in this. They appreciated that people's memories of holiday scenes were more colorful and idealized than reality. Holiday skies, therefore, should be bluer, and this was achievable through the increasing sophistication of film technology. Printing

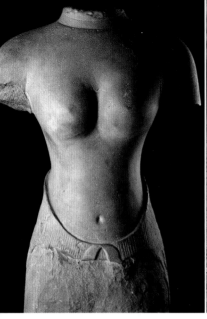

REFINEMENT

The side-lit torso of a Khmer statue offers a classic subject for black and white, with refined treatment of the subtleties of form and texture.

HOLIDAY SKIES

A Velvia sky, courtesy of Fuji chemists who recognized the desire of most holidaying photographers to reproduce blue skies as they think they should be rather than as they are.

for publication offered the same opportunities to ratchet up the colorfulness. Digital photography has unfortunately made color excess even easier, and with the broader gamut of electronic screens, the internet displays all of it.

Black and white, not surprisingly, looks all the better by comparison. Ian Jeffrey, who was quoted above, takes the view that "Polychrome worlds are both radiant and genial…Monochrome promised insights, visions of reality purified; or it allowed photographers

freedom from the contradictory richness of full color, and a means toward emphasis and control—advantages not lightly sacrificed." Or, as Cartier-Bresson put it: "Black-and-white photography abstracts things and I like that."

Contemporary black-and-white photography has, at least as I see it, evolved into two reasonably distinct strands. One deliberately continues the ethos of gritty documentary style; the other explores the textural, even tactile and sensual, qualities of the finely crafted

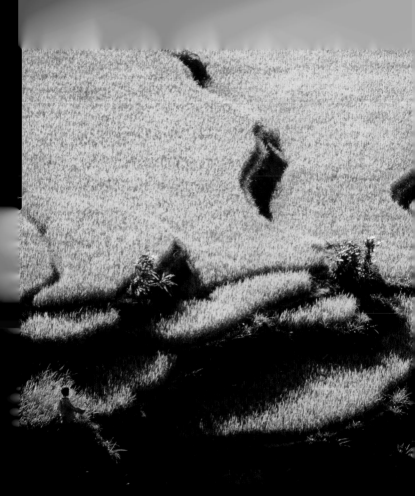

"POLYCHROME WORLDS ARE BOTH RADIANT AND GENIAL"
The "radiant and genial" appearance of "polychrome worlds," in the words of
Ian Jeffrey, is exemplified in the glowing rice fields of this Balinese terracing ready

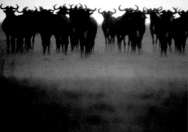

ABSTRACTING THINGS

By removing color and by manipulating contrast, this view of wildebeest on the Serengeti plains attains an abstract graphic quality divorced from the situation itself.

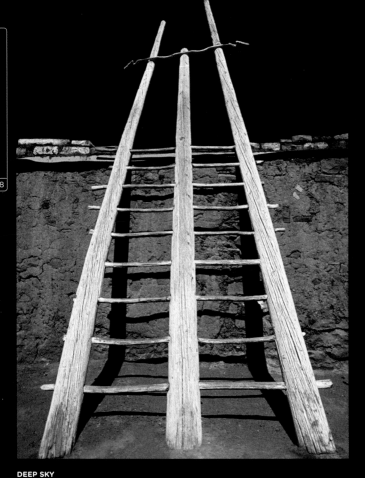

DEEP SKY

Strong geometric abstraction of an old ladder in
the clifftop New Mexican settlement of Acoma.
The deep blue sky was easy to convert to black,
for maximum contrast with the bleached wood.

TEXTURE

The textural, tactile qualities of a black-and-white print are of prime concern—the difference between semi-gloss and matte is demonstrated here.

print. In some work, of course, the two come together briefly. This far along the historical road, decades past the introduction of a full choice between color and black and white, attitudes toward black-and-white imagery can be self-conscious. This surfaces in documentary photography, in which there is a strong feeling for continuity with the great reportage photographers of the past, such as Walker Evans, Brassaï, Henri Cartier-Bresson, Robert Capa, and others. Of course, there is also, and perhaps more importantly, the traditional argument that removing the distraction of color helps to focus attention on the meaningful activity in the scene, but the sense of following in a great tradition still pops up. Ian Jeffrey's comment that "urgent black and white" is somehow and unquestionably "apt" for serious documentary issues is typical of many thoughtful collectors, commentators, and curators. People who take photography seriously take black and white even more seriously. Consider a major recent sale in 2008 by New York's Swann Galleries of *Important 19th & 20th Century Photographs*. Of the 389 lots, 364 were monochrome.

Not unexpectedly, collecting photography is biased toward safety, which favors older prints by known masters, and many people are still uncertain about the archival qualities of color prints. Nevertheless, this strongly skewed respect for monochrome prints suggests that black and white is perceived as being more serious, more at the heart of photography than mere color.

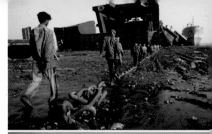

Without Color

Pictures without color can convey altogether different qualities to the original, which is inevitably color in the world of digital.

ALANG SHIP BREAKING

In the black-and-white conversion, the distraction of the color is removed, allowing the eye to concentrate on the figures and the mind to consider their labors.

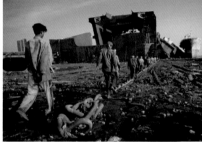

GRAIN SACKS

The color original is confusing, with the red lifeboat demanding too much attention. In black and white, the central protaganist is seen more clearly.

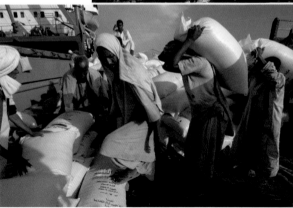

DELHI BOY

Opposite: Black and white's reputation for "gritty reality" suits it to reportage subjects such as these.

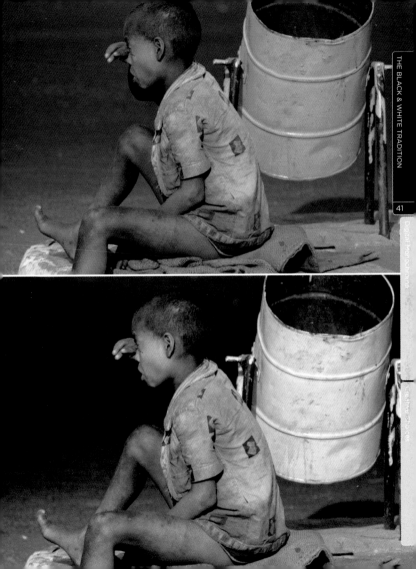

Subtracting Color

At the risk of oversimplifying, subtracting color from imagery allows the other graphic elements and dynamics to increase in importance. Indeed, compels them to, like a sort of Boyle's Law of attention—fewer components in an image expand to engage the attention of the viewer.

Color is so integral to our experience of the world, and of imagery, that most people (and most photographers) do not separate it in their mind's eye from everything else that is going on. In order to understand what happens when we take it away and work in monochrome, we need to know how it fits in to the total range of image qualities; also, how it differs from the other elements in its effect.

Moreover, color elicits subjective and emotional responses in a way that other image qualities do not. Without normally analyzing it, we tend simply to like or dislike in varying degrees the way a certain color looks, or a combination of colors. The subjective response to color is powerful and pervasive, and as a result, takes over viewer response to many photographs. If the color component in an image is strong, rich, unusual, or simply noticeable, there is a good chance that it will swamp the attention. Many photographers, perhaps too many, have exploited this and concentrated their energies on the power of color. Once the chemistry of color film was properly established in the early 1960s, the opportunity to concentrate on it as an image quality began to be exploited by a

RUINS

In this image taken in the abandoned Khmer ruin of Banteay Chhmar, with its inimitable face tower, the color version distracts without adding any particular value, while a black-and-white rendering pulls attention back to where it was intended—on the face tower.

number of photographers. One of the most influential was the Swiss photographer Ernst Haas, who notably exploited the strong, but dark, color saturation that Kodachrome gave when slightly underexposed. By contrast, Eliot Porter worked with a more restrained palette, but still with a sensual approach in which the colors themselves are often the principal reason for the photograph.

And because color triggers emotional responses, there is also usually an unquestioned assumption that it works on a scale of beauty, or at least attractiveness. To say "what a spectacular sunset," or "look at how blue the water is," or "that gray really sets off the pink," or any of the many other common value judgments on color, is to acknowledge that the effect of color can be likeable— and for most people should be likeable. This gut reaction to color is by far the most common, and in this way it stands apart from the other formal graphic elements, which we'll now examine. There are a number of ways of subdividing the graphic components of an image, but the most generally accepted are: point, line, shape, texture, and color. In the way that these are used and interact, there is

ABU SHOUK

Left: A Sudanese woman from Darfur, recently arrived in a refugee camp after her husband was killed in an attack on their village. Arguably, the bright colors favored by all Sudanese women detracts from the severity of the situation.

contrast, balance, and dynamics (or vectors). Subtracting color enhances those remaining. In practice, this means that the components and qualities most affected are the graphic ones of shape, the graphic structure of the image, and the gradation along the gray tonal scale, as well as the three-dimensional ones of volume and texture.

Shape

Shape in photography can be pushed in two directions. One is toward the two-dimensional and graphic—"pure" shapes that behave as cut-outs, as in a strong silhouette.

The other is toward creating the impression of volume, roundedness, and three dimensions. In either case, the emphasis is on formal graphic structure. As Joel Meyerowitz, another photographer who moved from black and white to color, put it, "it was a big step to cut off black-and-white work and commit myself to color. You're really changing the nature of your response. It's a very different game out there. Black and white has more form. Somehow, pictures look like there's a compressed formal structure running through them, tying events together. In color, there's more of a languid flow from one thing to the other. Learning how to make that switch was a departure for me."

In fact, although here I'm isolating the particularly black-and-white qualities of photography, beginning with shape, they are all interconnected. Shape can be used to define form, although not necessarily. This in turn gives a sense of volume and presence. Shape depends heavily on outline, and in photography this is defined by edge contrast, as opposed to in drawing, where lines are more normal. This contrast in itself draws more attention to edge transitions in monochrome than in color, with all the attendant issues of sharpness, smooth gradation (in the case of a soft or defocused edge), and possible artifacts such as halos when you apply sharpening.

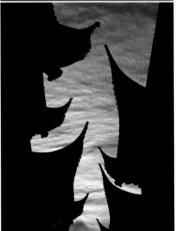

SILHOUETTE SHAPE

Above: Shape based on the edges of a silhouette is clear, graphic, and two dimensional. While the sunset colors are fairly attractive, this image is nevertheless a candidate for black and white because of its graphic qualities. The removal of color further keeps the attention on the outline of these old Shanghai roofs.

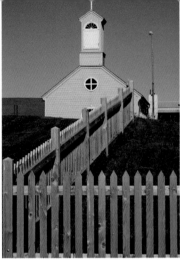
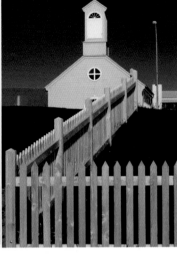

EITHER WAY

Above: An image, taken in Iceland, that works perfectly well in color or black and white, though differently. The black and white is arguably stronger, at least when processed this way for good contrast, with the shape of the fencing and white church emphasized.

LIMITS OF SHAPE

Below: A cropped detail showing two ill effects from over-sharpening (in the right-hand image). One of these is haloing around the edges, particularly noticeable around the horse's ears; the other is an exaggeration of noise in the shadows of the horse and rider.

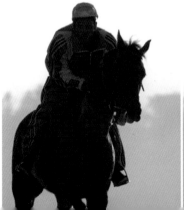

Structure

Composition in photography can be subtly embedded, so that the viewer is unaware of it. However, it can also be strongly evident, and this depends on two things: whether or not the photographer wants to push this particular graphic aspect of the image, and the opportunities that the scene offers.

Image possibilities that contain a strong potential for structure notably include elements of line and shape, almost always heightened by some form of contrast. These conditions, and the images here, are just two of countless examples that create what Henri Cartier-Bresson described as the "geometry" of a photograph when he said, "I think of what I see, and the geometry, that means everything has to be composed properly." He also wrote of composing as seeing "...the beauty of the form; that is, a geometry awakened by what's offered."

Black and white enhances these possibilities by taking away the distraction of color, forcing more attention on the contrast across edges, as the two examples on these pages show. In Frank Lloyd Wright's Guggenheim Museum image, the interior is not particularly colorful, but even so, the differences in color from the mixed lighting contribute nothing to the image and simply serve to distract. In black and white, the image is stronger and cleaner. In the other image, under a hill-farmer's house in southern China, the wooden construction, the relationship between calf and buffalo, and the exaggeration of all of this by using a wide-angle lens (at 27mm focal length), create the potential for pronounced geometry. Again, however, the cool-warm color contrast works across this. Here, careful processing made the most of the structure, and we will look at this in detail later on page 154.

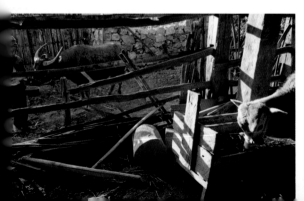

ALTERNATIVES: CHINA

Color and black-and-white versions of a scene in a hill-tribe village in southwestern China.

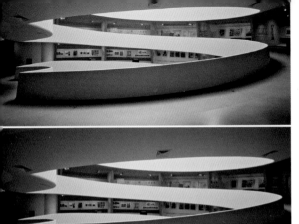

ALTERNATIVES: GUGGENHEIM

A view of Frank Lloyd Wright's Guggenheim Museum in New York, both in color and in black and white.

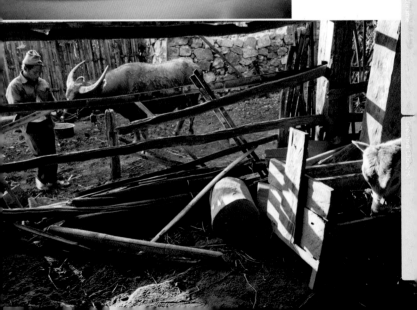

Tonal Nuance

This is a very specific photographic concern, by its nature subtle and personal. If you study the examples here with some care, you can see how complex the issue of brightness can be in a color image.

Physiologically, our visual system responds more sensitively to some hues than to others, which is why yellows and yellow-greens are brighter to our eyes. But more than this, there is our psychological response to different hues. One simple example of this is that "hot" colors around orange are readily associated with flame and burning, and also the production of light. Most people feel these to be inherently brighter than, say, blues, which we tend to associate with water, coolness, and dim light. Further proof is the huge choice in translating hues into tones when you use one of the various software processing methods that mixes channels (as demonstrated opposite, and we will see in considerably more detail in Chapter 3).

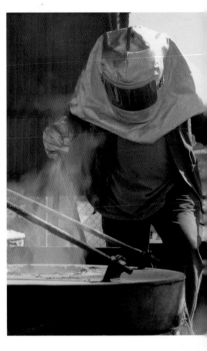

Take this away, and the tonal scale simplifies dramatically. What this allows is a clearer, purer concentration on the subtleties of transition between shades of gray. Immediately, as you would expect, this places great importance on the smoothness of tonal gradients, such as in a clear sky. Unevenness, and in particular banding, is even more apparent with no color to distract the attention. Long smooth gradients show up the efficiency of the sensor, and make 16-bit-per-channel processing a priority.

On a more subjective level, there is extra room to play with tonal transitions in different areas of the scale. You might, for example, want delicacy in the upper mid-tones in particular, or very finely tuned hints of detail in deep shadow areas. All of this naturally leads to different interpretations of tone which, as we'll see in a few pages, has a wider range of acceptable results in monochrome than in color.

I mentioned channel mixing in software monochrome conversion, which you would do as part of your Raw processing (providing that you shot Raw),

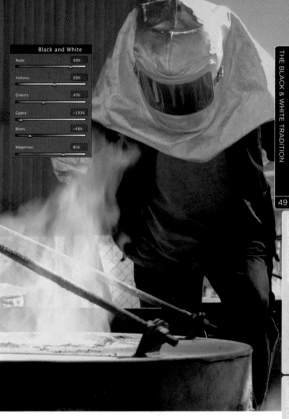

DESATURATED

In color, this image of gold smelting clearly stresses the intensity of the flames, whereas a straight desaturation (above) loses the impact completely. Recovering the tonal distinction (right) involves operating the sliders in hue adjustment to darken the man's protective suit and brighten the orange flames.

but which can also be performed on TIFFs. This, of course, adds another very large dimension to controlling tonal nuance. It makes it possible to achieve almost any conceivable distribution of tones, with almost too much choice. It certainly demands a clear idea of what you want to achieve, ideally before you begin the process.

Form & Volume

Form and volume both play an important part in revealing each other, with texture key to the viewer's understanding of the picture.

In their classic *A Concise History of Photography*, Helmut and Alison Gernsheim put the issue of shape and form succinctly when they wrote, "In monochrome the massing of light and shade and the reproduction of texture are of the utmost importance," making the comparison with color photography.

We'll deal with texture on the following pages, but for many black-and-white photographers, this massing that uses brightness is the key concern in technique. Eliot Porter, who began in black and white, but made his reputation in color, was unequivocal when he wrote that, "When photographing subjects like rocks, the approach is entirely different, because in black and white you see the forms much more than you do in color."

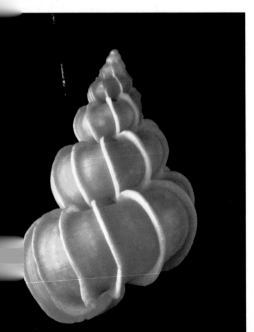

PRECIOUS WENTLETRAP

With diffused lighting from the left and a reflector on the right, against black velvet, the setting, lighting, and processing for this still-life of a precious wentletrap have been chosen primarily with a view to emphasizing the volume of the shell, so that we can sense its three-dimensionality and delicacy.

BRONZE STATUE

Opposite: Side lighting, a hint of secondary lighting from behind and left, and a low-key treatment combine to stress the form of this ancient Khmer bronze statue.

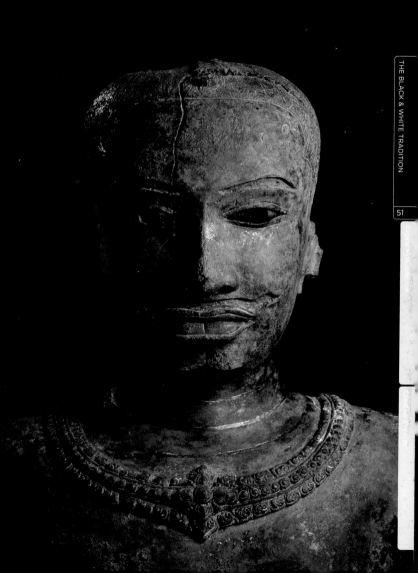

Texture

Texture is structure and form on a small scale, meaning small relative to the view. And, because a texture is, by definition, something that is reasonably consistent over a substantial area of a surface, it is usually a repetitive structure.

A pebble-dashed wall, to give an example, has a particular consistency of roughness and spacing. The reason why texture becomes a more prominent, malleable quality in black and white than in color is—as we've already seen for shape and form—removing color from the equation makes the presentation of texture a pure exercise in tonal modulation.

The simple way of treating texture in a photograph is in terms of its strength, and almost any relief texture looks stronger under a point-source light that casts hard shadows, and in particular, under raking light from a low angle. However, this is not just simple but quite simplistic. There is an infinite variety of texture, including smooth glosses and metallic sheens, and the key to handling texture is to connect it to the object whose surface it covers, and what you want to say about it in the image. If, for example, a ceramic vase or bowl has a pronounced and gritty texture, how much do you want to stress this aspect rather than the volume? Almost certainly there will have to be a compromise. These kinds of possibilities and decisions are endless, and there are certainly no rights or wrongs. The place you give to texture in an image is entirely your choice—in as much as you have control over the lighting which, ultimately, reveals texture.

BRACES

Another lighting technique that reveals texture is this—a large, diffused area light aimed from in front of the camera but out of frame. This method lit the entire stone slab on which these old braces were placed, while showing its texture.

BADRUTTS

The metallic texture of an embossed letterhead in silver called for a variety of light falling on it to convey its texture. The solution was a spotlight aimed through an empty wine glass to throw caustics over the close-up, plus strong fill from a reflector on the right.

BADRUTTS SILVERWARE

Hotel silverware in close-up. The texture, in this case, includes lettering and a symbol that need to read clearly. The answer is an area light, but not so large that its reflection swamps the entire curve of the metal.

Interpretation

One theme running through this book is that monochrome, by being distanced from what we take in through our eyes, allows more extreme manipulation without breaching any norms of acceptability.

Let me expand on this a little. Color photography, despite coming late in the twentieth century to the photographic world, carries with it, automatically, the presumption of being close to reality. It's expected in most instances. Or rather, it's unquestioned. Make major alterations to a color image, such as hue changes, selective changes, and they will very definitely look like alterations. Adjustments at the same level of intrusion in black and white, however, are accorded much more latitude by most viewers.

We'll come to the large-scale possibilities later, in Chapter 2 when we look at processing, but for now let's limit ourselves to three moves that are both basic and common to both color and monochrome. These are tonal compression, brightness, and global contrast. The argument is that you can push each of these acceptably to a more extreme degree in monochrome than in color. Any judgments here are subjective, of course —a matter of taste—so it's perhaps better that I'm not didactic here. Better to let the examples speak for themselves. Tonal compression means clipping at either or both ends of the scale, which is usually more acceptable for the shadows because of the long photographic tradition of the silhouette; much less so for the highlights. Even so, it can work perfectly well for a black-and-white image. Altering brightness is basically a change of key (between high-key and low-key), which we explore in more detail later. Local contrast affects the entire image, while the ends of the scale remain fixed, and is traditionally altered by applying either a classic S-curve or a reverse S-curve.

STAGES OF INTERPRETATION
Creating the perfect black-and-white image can involve a number of stages, including —as here— the use of masks to target specific areas for different tonal treatment.

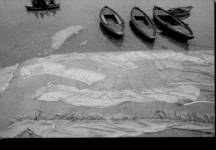
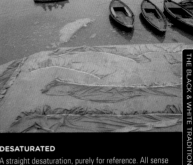

DHOBI WALLAH

The color original, of yellow cloths drying on the banks of the Ganges at Varanasi.

DESATURATED

A straight desaturation, purely for reference. All sense of contrast in the cloths has been lost.

BLACK & WHITE SETTINGS 1

Using hue adjustment, I aim for a contrast that will have the cloths light and the river dark; raising yellows and greens, lowering blues and cyan. This certainly achieves contrast, but vignetting that was present is exaggerated. Also, both the cloth highlights and the dark shadows in the upper half need tempering.

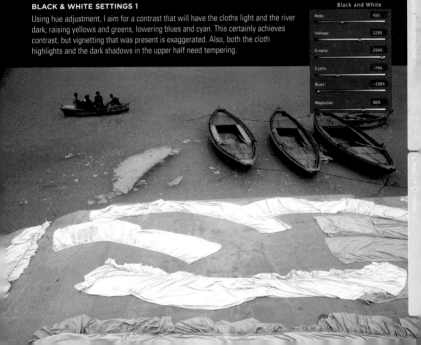

Black and White

Reds:	45%
Yellows:	125%
Greens:	294%
Cyans:	-79%
Blues:	-198%
Magentas:	80%

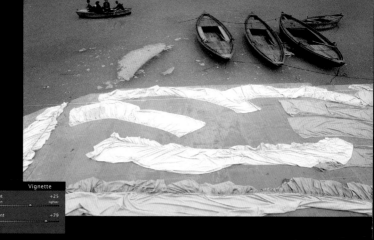

BLACK & WHITE SETTINGS 2
Using Lens Correction in Photoshop, the vignetting, most prominent in the upper corners, is reduced.

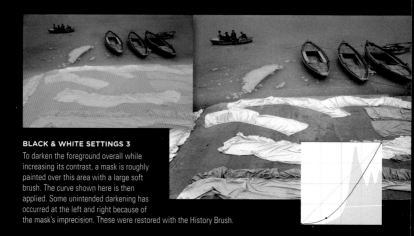

BLACK & WHITE SETTINGS 3
To darken the foreground overall while increasing its contrast, a mask is roughly painted over this area with a large soft brush. The curve shown here is then applied. Some unintended darkening has occurred at the left and right because of the mask's imprecision. These were restored with the History Brush.

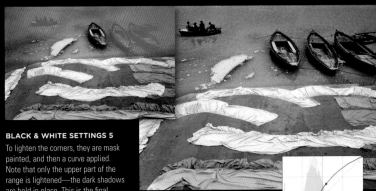

BLACK & WHITE SETTINGS 4

The next step is to heighten contrast in the river, with its boats, to get a gritty feel. The river area is selected by mask painting as above, intentionally leaving a gap in the middle of the boats on the right-hand side, which are already very dark. A strong contrast- creating S-curve is applied. Now, some unevenness across the water has crept in, leaving the top left and right corners of the image too dark.

BLACK & WHITE SETTINGS 5

To lighten the corners, they are mask painted, and then a curve applied. Note that only the upper part of the range is lightened—the dark shadows are held in place. This is the final image—clearly just one interpretation of several possible ones.

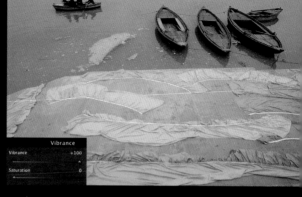

LIMITS OF COLOR

What we have done earlier in black and white is to make strong, even extreme, adjustments to the image as shot. Now I want to show the limits of adjustment if we were to work in color.

COLOR SETTINGS 1

These limits are much tighter. First, let's apply 100% Vibrance (which is, by its design, less extreme than the same Saturation increase would be). Even then the result has already gone beyond what most people would consider reasonable.

COLOR SETTINGS 2

Below: If, instead, we decide to shift all the hues, there is even less latitude. Here 15%, which is very little, is about as far as we could go and still maintain some semblance of naturalism.

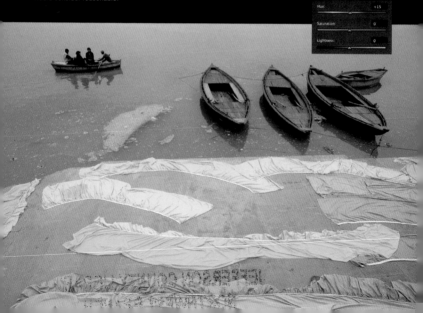

COLOR SETTINGS 3

Finally, let's see how strong a standard filter we can apply and still seem natural. This is a basic warming filter, and the overcast light might suggest it. But applied at 50% we have quite a different effect, almost like a colored monochrome! The lesson from these three color experiments is clear—black and white lends itself to greater extremes of processing interpretation than does color.

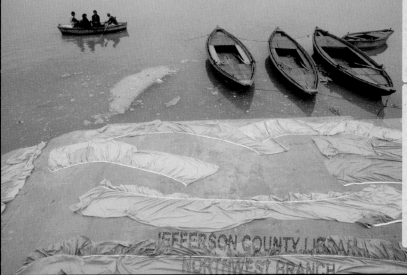

Film Qualities

The particular look of film has been around long enough to be an established part of our cultural understanding of the image, even if it is no longer present in many of the pictures that we are presented with. It carries with it certain expectations of truth.

Every medium adds its own internal qualities to an image, be it oil paint, charcoal, watercolor, or film. And for photography, emulsions, both film and paper, have dominated it for so long that their particular characteristics are embedded in its language. Consider the history of black-and-white emulsions. Over the course of the late nineteenth century and most of the twentieth century, many monochrome film emulsions were invented, each with a different quality, varying by a mix of grain and texture, contrast, tonal structure, and other things that was hard to pin down, but nevertheless made most of them identifiable.

Graininess in film is caused by silver particles clumping. In fact, when people talk about grain in film, they usually mean much larger structures, as individual grains are normally impossible to see at normal viewing distances. This goes back to the structure of an emulsion, in which silver halide crystals are suspended in a matrix. They react latently (meaning not at the point of exposure) to light falling on the film, and processing converts these exposed crystals into black silver. That, skipping the details, is the essence. The silver halide is the active ingredient in film, in the form of a mass of crystals

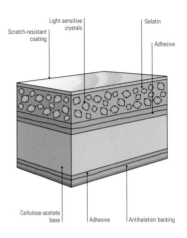

FILM STRUCTURE

In a typical black-and-white film, the emulsion is a layer of gelatin in which the light-sensitive crystals of silver bromide are embedded. This is supported on a tough, stable base, usually cellulose acetate. A scratch-resistant coating protects the emulsion and an antihalation layer prevents stray light from being reflected back into the emulsion from below.

distributed as evenly as possible in the gelatin layer that makes up the body of an emulsion. The size and distribution of these crystals, also commonly known as grains, varies according to the type of film, but in an average emulsion each measures about 1/1000mm across. The silver and halide components are held together in a lattice arrangement by electrical bonds; when the photons strike, they disrupt the electrical status quo by adding energy to the crystal.

One of the special qualities of film, lost in digital sensors, is that it responds to

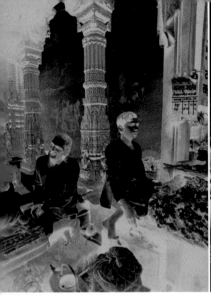
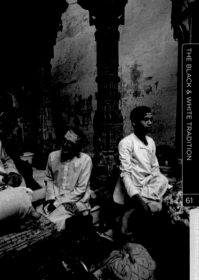

JUDGING NEGATIVE THEN PRINT

Black-and-white printing from negatives demanded experience to be able to "see" the image from its tonally reversed negative.

brightness in a way that is quite similar to the human eye. Basically, it can handle a wide range of brightness (dynamic range, in other words) by compressing its response. Put more practically, it means that as more light falls on the film, the emulsion responds more sluggishly.

Most of the improvements and alterations that film manufacturers used to make to their products had to do with the size and shape of these grains, and the way in which they are suspended in the emulsion. To make a film more sensitive to light, a greater area of each

affected grain needs to be exposed. Traditionally, this was done by using larger grains, but a more modern development is to use grains that are flatter rather than lumpy; if they lay flat-side toward the light, the effect is greater sensitivity without more silver halide bulk. Film with larger, or flatter, grains reacts more readily to light and is therefore "faster." However, the price that has to be paid for this increase in film speed is a coarser image, more so with large-grain than with flat-grain technology. The increased granularity gives rise to a grainier appearance, which in the very fastest films or with great enlargement actually breaks up the image into a pronounced speckled texture. To maximize image quality, film manufacturers set smaller grains into a

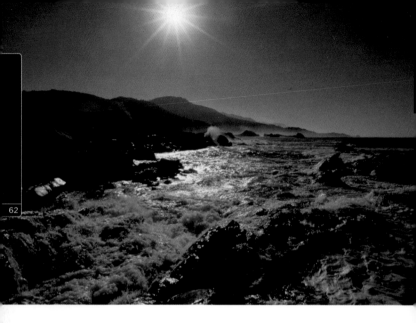

thinner emulsion, so as to reduce the internal reflections that degrade the image in a thick layer of gelation. This type of emulsion has a fine-grained appearance, but reacts less well to light and is therefore "slow." The improved sensitivity of flat grains is also used in combination with cubic grains for fine-grained emulsions that can produce exceptionally sharp images. Even distribution of the crystals and a fine internal structure contribute to this.

The net result of all this effort is that different film emulsions have different styles of graininess, and many photographers who are wedded to film feel able to discriminate between brands. How real this is matters less than that film photographers certainly used to

HIGHLIGHT ROLL-OFF

Even shooting straight into a bright sun on a clear day, film handles the excessive contrast quite gently in the highlights. The tones roll off gradually toward the solid white of the sun, with no obvious banding.

favor the grain structure of certain films, and generally learned to appreciate this quality. Kodak's Tri-X was always well regarded for this. Philosophically, you could argue that even though film manufacturers have always tried to minimize the appearance of grain, it remains structurally a part of the process and of the image, and so should be accepted, and even loved, for that reason. There are certainly many examples in black and white of photographers emphasizing and using this quality.

BIRDS

George Krause, 1965. This is a photograph that relies heavily on revealing the grain in order to create what the photographer calls "an image that suggested a Seurat pointillist drawing or an intaglio aquatint." To this end he exaggerated the effect by later applying Victor's mercury intensifier. Krause, a renowned printer as well as photographer, has since moved happily to digital black and white. Courtesy: The Artist.

TRI-X

Tri-X in magnification shows the distinct and definite grain structure prized and enjoyed by many film photographers.

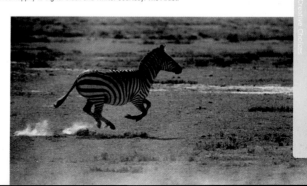

There is also a paradoxical relationship between graininess and sharpness. Sharpness is a subjective quality, to which the measurable quality of resolution contributes only partly. Other things come into play, including contrast, and sharpness is very much a matter of judgment, as becomes immediately obvious when people discuss it. "Not sharp enough" and "too sharp" or "over-sharpened" are clearly expressions of taste. At a degree of enlargement when it becomes visible, and especially with high-speed and pushed film, grain can act to help sharpness. Even though overall the less noticeable the grain, the sharper an image looks, in its detail, graininess with a precise structure can, just by giving a definable texture to the image, provide a different kind of sharpness.

However, grain in color film is not the same thing. To begin with, at a microscopic level, the crisp black silver of black and white is replaced with a rather fuzzier dye cloud. Then, a tri-pack color emulsion has more depth, with overlapping color dye-clouds adding to the softness. What is visible in a high-speed black-and-white film image as a crisp structure becomes more amorphous in fast color film. One different monochrome process borrows some of color film's technology. In such "chromogenic" films, the original silver is removed after the first development, and replaced with a dye. The result is a virtual absence of the traditional grainy texture, which was not a foregone advantage for the reasons discussed above.

Interestingly, some image processing software manufacturers have caught on to

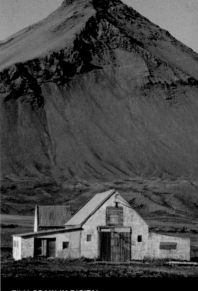

FILM GRAIN IN DIGITAL

In these examples, DxO FilmPack, a software processing application, offers measured simulations of a selection of 60 films, not just the grain characteristics, but the characteristic curve response. As the company puts it, this is from "modeling the colorimetric responses of silver-halide films. For the modeling process, great care was taken in the development of these films, which was entrusted to major professional laboratories in Paris and New York."

this latent desire among photographers to recreate the look of traditional films, and in particular their graininess. The result is presets that make an image look as if it were shot on a specific brand of film. The examples here are from DxO FilmPack.

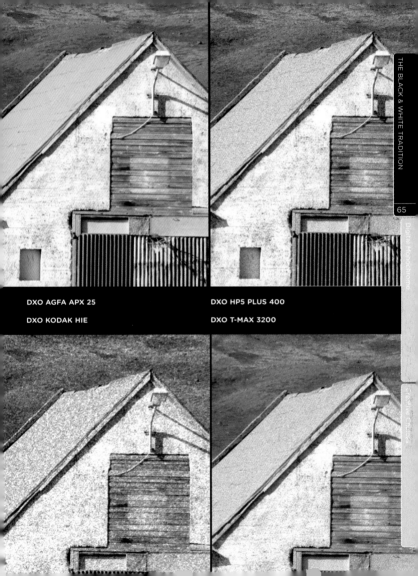

DXO AGFA APX 25

DXO KODAK HIE

DXO HP5 PLUS 400

DXO T-MAX 3200

DIGITAL MONOCHROME

While digital photography is for the most part practiced in color, camera sensors are strictly monochrome. But of course, so is film. Both react to the quantity of light and not to sections of the visible spectrum. Also, both need a process of color separation in order to record and reproduce the colors of the world.

In the case of sensors, the near-universal method is a grid of colored filters—red, green, and blue—attached to the front of the sensor. The alternative is the Foveon sensor, in which three layers—blue at the top, then green, then red—are stacked, on the same principle used by tri-pack color film.

Black-and-white photography with a digital camera, therefore, is something of a retro operation, as the color information needs to be removed. However, far from being a disadvantage, the color information can be put to excellent use in allowing the brightness of any color to be adjusted as you convert it to a shade of gray.

For anyone coming to this from black-and-white film photography, there are several key differences. First, camera sensors react to light in proportion to how much strikes each individual photosite,

while film has a generous latitude that causes it to be more forgiving of overexposure, and to some extent underexposure. In a digital exposure, the sudden loss of highlights from a slight miscalculation and overexposure is always a concern. The camera sensor has two critical limits: highlight loss, or clipping as it is known, at the top end, and noise at the other end in the shadows.

Much of this chapter is devoted to hue adjustment. This is the post-processing stage in which you can choose and fine-tune the brightness relationship between different colors in any scene. The blue of the sky, for example, can be lightened or darkened independently of the overall exposure, simply by adjusting a blue or a cyan slider. The technical side is straightforward; much more interesting is deciding when and why to use these powerful controls.

The Monochrome Sensor

Like film, and every other photographic process before it, camera sensors respond to total light, not color.

In order to extract the color information from a scene, the total light reaching the sensor needs to be filtered. Filtering simply means blocking some wavelengths in order to allow others through, and the standard method for almost all camera sensors is the Bayer array, a mosaic filter manufactured with a pattern of red, green, and blue. Each photosite is filtered with one or the other, and the standard arrangement has twice the number of green filters than red or blue, to match the sensitivity of the human eye, which has its peak response to yellow-green wavelengths.

This arrangement means that the color information is much less than the light information, and the camera's processor uses interpolation to guess the mix of color for each pixel. In practice, this works perfectly well, even though it sounds crude, but to get back to monochrome, the colors need to be desaturated. This is indeed what happens in cameras that offer the option of monochrome—a straight desaturation of each of the three channels: red, green, and blue.

The hidden advantage of shooting color when you really want black and white is that later, when you come to process the images on the computer, this color information can be used to vary the brightness of specific hues. For more on this valuable feature of digital capture, see Colors into Tones, page 104, and the pages following.

Another way of shooting in black and white is to have a monochrome sensor— that is, without the Bayer array in front of it. And that is exactly the route Leica have taken with the M-Monochrom, a black-and-white version of their M9 full-frame camera. The argument for this is simply that the resolution and contrast will be better without the Bayer array.

BAYER FILTER

In the Bayer filter bonded to the front of most camera sensors, a pattern of red, green, and blue filters cover one photosite each. The color resolution is thus much lower than the spatial resolution.

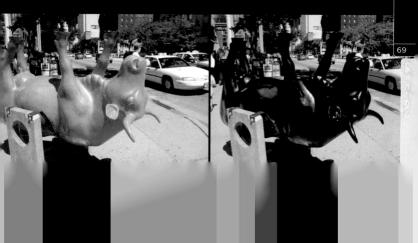

RED COW

In this strongly colored image of a bull sculpture
in Chicago, the green and blue channels almost
completely block the red.

BLUE CHANNEL

Linear Capture

The idea of linear capture arrived new to photography with digital. Because film responds differently to light than a digital sensor, the matter was of no relevance before. Now, especially when we are delving deeply into the digital process, it needs to be dealt with and understood.

Basically, linear in the context of photography means a straightforward, one-to-one response to light. This is what a sensor does. It counts the photons, photosite by photosite, and delivers a signal that corresponds exactly to the numbers. That sounds uncomplicated, basic, and normal, but it is not the way that we perceive light. Nor is it the way that film responds. Both the eye and film react to light in a very non-linear way.

They compress the information, with the very significant advantage that they can sense a wider range of brightness than they would otherwise. This compression effect, essentially a log scale of sensing rather than a linear one, affects other senses as well. If you hold a 100-gram (3½ ounces) weight in your hand, then add a second, the combination feels less than the full 200 grams.

Because this is the way we see, any imaging system that plans to deliver realistic looking photographs has to conform to the eye's non-linear processes. Film has a similar built-in compression. In practice, this means that highlights recorded on film don't just disappear suddenly into blank whiteness, but hold up quite well. In a landscape view in which the sky, for example, shades from a light gray cloud to the intense brightness

Gamma

The term gamma is used often in computing and in describing digital images. When applied to monitor screens, it is a measure of the relationship between voltage input and the brightness intensity, and because of the way a computer display works, a Raw, uncorrected digital image would look darker and more contrasty than our eyes would find normal. To compensate for this, gamma correction is applied inside the camera after capture, as the exercise will help you to understand. The typical gamma correction curve shown here has the effect of making an image brighter (because most of it is shifted to the left) and less contrasty (because of its shape, which lifts dark tones more than light ones).

GAMMA VARIATION
The effects of lowering and raising the gamma.

Gamma lower

Gamma higher

of the sun, black-and-white negative film will capture more than you might expect. And the same goes for the shadows.

A Raw digital image, however, does not work like this. For a start, most of the bits used to encode the capture are devoted to the brighter end of the register rather than the more visually useful mid-tones. A Raw histogram, as shown in the example here, looks strange to anyone used to working with histograms in, say, Photoshop, with most of the values squeezed to the left. Secondly, as brightness marches in step with the photons counted, there is none of the gentle roll-off in the highlights that happens with film. In an area of an image that shades from bright to white, there is a sudden break point and a resulting edge that looks unpleasantly artificial.

Because of this, digitally captured photographs always need to be adjusted with what is called a gamma correction. A typical one is shown here, and in effect it brightens the shadow areas while tailing off toward the highlights. The camera applies one of these when it processes the image just shot into a JPEG or TIFF. If you shoot Raw, the preview you see on the camera's LCD screen is actually taken from a JPEG. One of the most convincing arguments for shooting in Raw is that the processing power of your computer, combined with the sophistication of image-processing software, far exceeds that available in the confines of the camera's processing system.

Gamma correction

LINEAR PROCESS
The linear capture as it would appear without normal in-camera processing.

GAMMA CORRECTION
A typical gamma correction curve as applied in the camera to bring the image to an appearance that seems normal to our eyes.

The Clipping Problem

As just explained, one of the problematic features of digital capture is that the brightness captured in the image is directly related to the exposure, and does not, as with film and the human eye, diminish at the upper and lower ends of the scale.

The problem of clipping is much more important for the appearance of the image, and especially in the highlights. An all-too-common result is a bright highlight ending up looking like a blank white patch with hard edges. It is debatable whether this looks worse in color or in black and white, but the argument for being especially careful in monochrome is that tonal gradation receives more visual attention when there is no color to distract.

Imagine a scene in which there is a steady increase in brightness across part of the frame, as in, say, a sky looking toward the sun, or a studio set-up in which a softened light shades across a plain white background. The latter is easy enough to create and test. What we want to see is a smooth, steady progression from mid-tones toward almost white. Given care with the exposure, this is easy enough to achieve shooting film, and even if the brightest point is actually a featureless white, the transition toward it will at least be smooth and appear acceptable. This is because the film's response to increasing exposure slows down. On the S-shaped response curve that used to be familiar to photographers working with film, we have here reached the shoulder. Film's diminishing response to bright light produces a gentle roll-off toward maximum brightness.

With a digital image, this is difficult. Moving toward the highlight, what typically happens is that the tones shade normally up to a point, and then suddenly change to featureless white. Hence, the apt term "clipping" is used to describe the sudden loss of values in digital highlights. The effect, as you can see here in the example, is an edge, which is unrealistic and definitely unwanted. The only way to avoid this is to reduce the exposure to the point at which there is no clipping, meaning for the highlights. If the contrast range in the scene is high, or even normal, this creates problems in the shadow areas, which will be underexposed.

The other solution is in the processing, or afterwards. One of the saving graces of shooting color in order to arrive at black and white is that the different responses of the three channels, red, green, and blue, can work to the advantage of recovering clipped highlights. Usually, the three channels respond differently to exposure, meaning that it is unlikely that they all clip at exactly the same point. As long as at least one channel retains some information, there is a chance to interpolate from that. Highlight recovery, a notable feature of Raw converters, attempts to reconstruct the detail information in a clipped channel from the other two, or even in two clipped channels from the third.

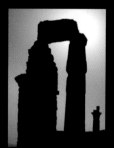

DEATH VALLEY DUNES

A film image, taken straight into the sun, in which the shading toward total overexposure near the sun is gradual.

HIGHLIGHT CLIPPING

By contrast to the Death Valley picture, a digital into-the-sun image shows a sharp break at the level where clipping (overexposure) begins. Holding down the ⌥/Alt key in Levels while dragging the slider reveals this dramatically.

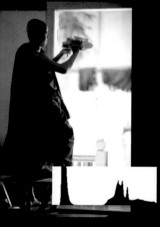

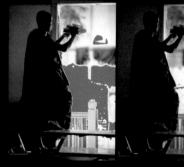

CLIPPED

Clipped highlights from normal processing, revealed in the histogram, which shows these crowded against the right side.

USING THE HIGHLIGHT SLIDER

The Highlight slider can be used to recover lost highlight information by using information that survives in one or more channels.

Noise, Bit Depth, & Shading

In the days of film, grain structure used to receive a great deal of attention from black-and-white photographers in particular; it is now time to look at the perceptual and even philosophical differences between grain and noise.

At first thought, noise and grain appear to have much in common. Both are artifacts that interfere with the image. They handicap it, holding back detail and tone. But film photographers saw grain differently from the way in which digital photographers regard noise. Noise is mainly a sampling error—not enough photons reaching parts of the sensor from dark areas of the scene. There are other causes, but the overall effect is that at high sensitivity and long exposures, pixel values are not consistent as they ought to be; instead, they vary and produce a blotchy, gritty result.

Grain, on the other hand, is generally considered a more acceptable image characteristic, as we saw earlier. First, it is embedded in the medium and is an integral part of the image-making process. Second, it has a distinct structure which can, with certain films, add a pleasing texture. This effect does not happen with digital noise, which, like hiss and crackle in a poor audio transmission, is simply evidence of a weak signal. Taste, of course, is an individual matter, but it is hard to imagine promoting the visual appeal of noise. One of black and white's advantages over color is that only luminance noise needs to be dealt with, not color noise, and the absence of color artifacts makes the overall effect less unpleasant.

Unlike grain, however, noise can be treated. There are several kinds and causes of noise, but by far the most common in most photography is associated with high ISO sensitivity settings. The amount of noise at different ISO settings varies from camera to camera, and depends very much on the sensor design. In particular, larger individual photosites are likely to suffer less from noise because they can collect more photons. Efficient Raw processing, particularly at the early de-mosaicing stage, also makes a difference. And, the appearance of noise can be reduced, even sometimes eliminated, in post-production. This last is by no means a perfect solution, however, as it tackles the effect, not the root cause, and there is always a trade-off between reducing the noise and an over-smooth, plastic-like appearance.

Closely related is the issue of smooth tonal gradation—and making changes to smooth tones. Just as favoring the blue channel when making a black-and-white conversion tends to enhance the appearance of noise, editing changes such as contrast curves also run the risk of creating artifacts. In particular, there is banding, in which there appear sharp breaks of tone in areas that ought to shade seamlessly. We saw an example of this earlier on page 49. With tonal shading across a wide area, such as with a clear sky through a wide-angle lens, any hint of banding is almost impossible to remove.

But why should there be banding in the first place? With a good sensor and minimal alterations in the processing, there rarely is. However, sensors with

ISO 100 **ISO 400** **ISO 1600**

INCREASING NOISE
Noise is most visible in medium-to-dark tones that are smooth and lacking in subject detail.

a low bit depth, as in cheaper cameras, can display this effect. And for any image, major processing changes, such as those to brightness or contrast, or by using one of the increasingly common local-contrast controls, runs this risk.

This is intimately related to bit depth. A higher bit depth, which for most of us means 16 bits rather than 8 bits, has more capacity to render a range of tones. 8-bit color, although perfectly acceptable for the final delivery of an image, is accurate to only 1 part in 256 per pixel. 8 bits per channel means that there are just 256 levels with which to reproduce the tones. High-end cameras record in 12 bits or 14 bits per channel. 12 bits measure to an accuracy of 1 part in 4026, and so is much better. 14 bits measure to 1 part in 16,104, which is better still. Nevertheless, by the time the image reaches the memory card, having been through the camera's on-board processor, it will be 8-bit if you

have chosen to shoot JPEG. If, sensibly, you shoot in Raw, these original 12 or 14 bits will have been converted to a 16-bit image for opening in, say, Photoshop's 16-bit mode. Provided that you do processing and post-production in 16 bits, the risk of banding is very much reduced. With an 8-bit image, on the other hand, as the example on pages 78–79 shows, after processing the histogram is quite likely to show a toothcomb appearance, with thin spikes. This damage to the image may show up only at high magnification, but for high-quality black-and-white prints, it is not acceptable. Because there is no color to distract in the image, artifacts like noise and banding are likely to receive even more attention from anyone inspecting the image closely.

HIGH-ISO ORIGINAL
A night shot, of a Christmas "cabalgata" in Spain, taken at the extremely high ISO of 25,600.

CROP
In close-up, the noise is expectedly disturbing in color, but less so in black and white when the chrominance component is removed. Looking at each individual channel, the noise is strongest in most images in the blue channel, least in green.

BLACK AND WHITE

RED CHANNEL

GREEN CHANNEL

BLUE CHANNEL

NOISE FILTERING

Noise can be filtered out during processing, but at a price. Compare these three Photoshop versions, the first with default noise reduction (0% Luminance), the second at 50% Luminance reduction, and the third at 100% reduction. The more you reduce, the softer and more "plastic" the effect.

DEFAULT NOISE REDUCTION

NOISE REDUCTION 100

NOISE REDUCTION 50

Original

Black and White

Reds	120%
Yellows:	105%
Greens:	40%
Cyans:	-150%
Blues:	-124%
Magentas:	80%

PRE-PROCESSING

To demonstrate the importance of using a high bit depth for major adjustments, a detail of this image is first converted to black and white.

16-BIT

When applied to a 16-bit image, the histogram remains intact through both changes.

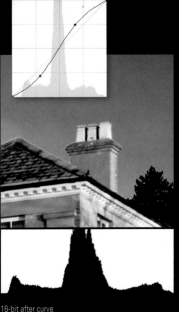

16-bit after curve

16-bit after Shadows/Highlights

8-BIT

However, when exactly the same changes are made to an 8-bit image, tonal information is lost, as evidenced by the toothcomb appearance of the histogram.

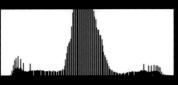

8-bit after curve

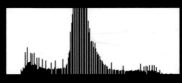

8-bit after Shadows/Highlights

Infrared

Monochrome infrared represents one of the most creatively useful technological breakthroughs in photography.
Used sensitively, it takes the tonal qualities in photography further from realism than any regular black-and-white process, and brings an exciting unpredictability. Infrared photography has been around since 1910, but was held back as a creative medium by two things: the limited choice of film emulsions, and the difficulty in planning an exposure. Digital infrared has changed both of these completely. Not only are there several ways of shooting in these longer wavelengths, each with its own visual characteristics, but the software processing allows a huge range of control. Moreover, the result is instantly viewable on the camera's LCD screen, making results more predictable.

First, let's take a look at the principle of infrared photography and how it worked with film. The sensitivity of the human eye ranges from about 450nm to about 700nm (from violet to red), and peaks at 550nm, which is yellow-green. Neither silver-halide film nor, as we'll see, sensors, capture the same range. Silver halides capture much more violet and blue than does the eye, but stop short of about 525nm. Special color dyes need to be added to film to extend its sensitivity even to visible light, and more are needed to extend the range into the near infrared. Infrared films are thus sensitive to visible light *and* near infrared. To photograph in infrared only, the visible light needs to be eliminated, and this calls for a visually opaque filter, typically a Wratten 89B or Hoya R72. This makes exposures long and means viewing and composing before fitting the filter over the lens. We could do the same with a digital camera, but infinitely better is to have the sensor doctored.

SENSOR CONVERSION

Professional sensor conversion in progress at ACS, a British specialist company (www.advanced cameraservices.co.uk).

Wavelengths

Daylight extends well into the infrared, but human vision stops just short. Unfiltered digital sensors peak in the infrared (hence their suitability for this conversion), and an infrared cut filter limits the sensor response to infrared by blocking longer wavelengths of visible light.

Unfiltered
sensor
sensitivity

MYAKKA RIVER

An image of palm trees in Florida's Myakka River reserve, shot on Kodak's black-and-white infrared emulsion (now discontinued). The pale vegetation and contrasty sky are typical, as are the pronounced grain and soft halation effects.

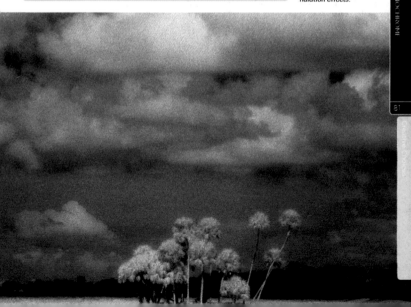

The reason I'm stressing the creative value of infrared is that if you agree with the argument that black and white releases creative potential in an image by stepping away from the assumed realism of color, then infrared does this to an even greater degree. Certainly, there are some well-known hallmarks of infrared monochrome, such as white foliage against inky black skies, but it is not even necessary to invoke these extremes. Because surfaces and objects reflect infrared wavelengths in ways that are unfamiliar to our eyes, the tonal scale and balance are unexpected and different throughout. This alone makes infrared a new visual world to explore.

At the shorter end of their range, infrared wavelengths begin at around the point where the human eye loses sensitivity, which is at about 700nm. To put this in perspective, the eye's sensitivity ranges from around 400nm to 700nm, peaking near the middle in the yellow-green part of the spectrum. Thermal imaging is at very much longer wavelengths. It is because we are simply not familiar with what things look like at wavelengths longer than 700nm, that infrared images have a strange appearance. That they can be imaged, but not seen directly is because film's sensitivity extends beyond that of the human eye into infrared. The situation is similar in digital photography: a silicon chip is naturally sensitive across a range from around 400nm up to about 1200nm, peaking at around 1000nm. Indeed, camera sensors are so good at picking up infrared emissions that during manufacture they are fitted with an IR Cut Filter (ICF) in front, also known as a hot mirror filter. Remove this, which is part of the process of converting a camera for infrared photography, and the infrared emissions come flooding in. The visible wavelengths, of course, continue to be recorded at full intensity, so that the second part of conversion is to fit a sharp-cut filter that restricts most, or even all, of the visible wavelengths. The most popular filter cuts at around 720nm, which allows just enough visible light in addition to the infrared to enable color infrared photography. And while our interest here is black-and-white infrared, the mild color response can be used to advantage by later applying hue adjustment, as we'll see on the following pages. For a pure monochrome infrared response, a filter that cuts at about 839nm is an alternative.

One more thing needs to be done to the camera, which is to reset the focus. As the infrared wavelengths are longer than those of visible wavelengths, they focus at a different point. This turns out to be more varied and complex than you might think, as different lenses refract infrared differently, but the bottom line is that the adjustment that needs to be made is to extend the lens a little forward, as if focusing closer. The amount is small, typically around a third of one percent, but the effect can lose acceptable sharpness at wide apertures. In the conversion process, the camera is reprogrammed, but even so, as most people choose the 720nm conversion,

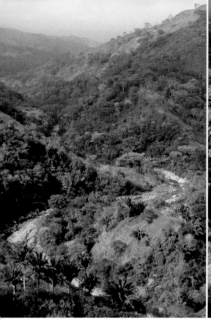
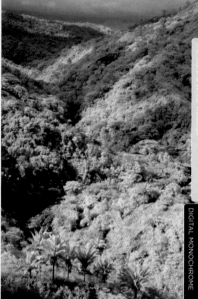

INFRARED, COMPARED
Digital infrared has less noise than the equivalent IR film grain, and also less halation. Here, in this view of a valley in Colombia's Sierra Nevada de Santa Marta, the pale green vegetation and atmosphere-cutting effects are both strongly evident.

which combines infrared with some visible, it's a wise precaution to stop down to at least ƒ/8 for safety.

In practice, what does this mean for shooting? In comparison with IR film photography, life becomes infinitely easier. You can see what you are doing, a result of sorts is available instantly on the LCD screen (and if the color is often way off, the exposure information is reassuringly accurate), and exposure settings are for

the most part within the handheld range. For example, on a sunny day at ISO 100, you could expect shutter speeds in the order of 1/200 second at ƒ/8. Also, in most situations, the dynamic range is well contained, meaning that clipping issues are fewer than usual.

Now, even though here our sole interest is black-and-white infrared, the color settings can still be important. While you can process as desaturated, if you have

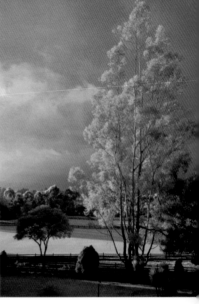

Raw infrared file

INTERPRETATIONS
The value of oversaturating a color version of the Raw file during Raw conversion is that it lets you use black-and-white hue adjustment to considerable effect. Here, the color contrast between sky and the eucalyptus leaves allows several alternative monochrome interpretations.

the ability to adjust the color balance and saturation, this gives you extra room to play with hue adjustment. In order to do this, however, we need to be able to neutralize any color cast. Because most of the recorded information is into the red and away from the blue, typical infrared files, as you shoot them, appear suffused with red and magenta, and need major white-balance adjustment. This is often more than most cameras allow, hence the importance of shooting Raw. Even so, Photoshop's ACR, for example, has a left-hand limit of 2000K for color temperature. One solution is to pre-set the white balance to a surface that responds strongly to infrared, such as grass. Another is to create

an infrared profile, as shown here. This is my preference, as it saves time when shooting. Then, once you have a more-or-less neutralized image, any features that are stronger in, say, blue or yellow, can be manipulated in the usual way when doing a hue adjustment (see page 108).

There is always some unpredictability when shooting in infrared, as the reflectivity of surfaces at this end of the spectrum can differ from the way they look—all part of infrared's charm. Vegetation appears very light, almost like snow, because the chlorophyll in the leaves fluoresces strongly in the near-infrared range, around 700nm. This effect is actually least noticeable in healthy, mature leaves and strongest in

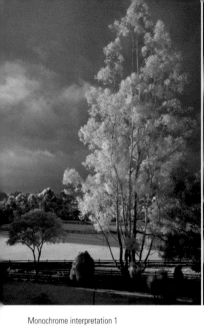

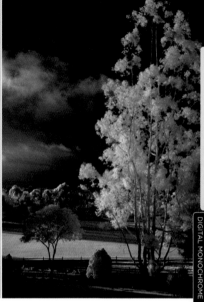

Monochrome interpretation 1

Monochrome interpretation 2

young, growing ones and in dying leaves. Another effect is that clear skies record very dark, and there is very good penetration of atmospheric haze. Both of these are due to a reduction of scattering relative to visible light. Probably the most typical infrared shot of all is a green-leaved tree and grass against a clear blue sky; while this is dramatic, it is also in danger of becoming something of a cliché. Human skin also changes its appearance, as these infrared wavelengths penetrate it to some distance, and the result is that skin appears lighter than in visible light. At the same time, what may not always be attractive in portraits is that the eyes tend to record dark, contrasting strongly with the pale skin.

Making a Profile for Infrared

One issue with an infrared conversion is the white balance, which after conversion typically falls below a Raw converter's color temperature limit (for Photoshop's ACR and Lightroom, for example, this lower limit is 2000K). Here is one way of bringing the white balance back into range, using Adobe's DNG Profile editor.

2. Select the Color Matrices tab.

1. First, make a DNG file from the Raw, using the Raw converter, and then open it in DNG Profile Editor.

3. Lower the color temperature and adjust the tint with the White Balance calibration sliders. In this case, the temperature needed to be taken to the limit.

86

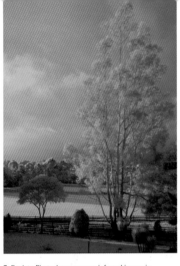

4. Adjust the other hue and saturation sliders to taste (there is no realism with infrared, so it depends entirely on you). If the final result for infrared images will be in black and white, stressing color contrast at this stage will give you extra control later when making a black-and-white conversion from the processed TIFF.

7. Back to Photoshop, open an infrared image in ACR and select the saved profile.

5. Go to File > Save Recipe in order to save the work so that you can edit later if necessary.

6. Go to File > Save Profile, too.

Your Processing Workflow

There are now so many digital processing possibilities and decisions that it is important to plan a logical workflow that suits the way you shoot.

In the new workflows, there is a trend toward concentrating as much of the processing as possible into the Raw conversion, which offers you the additional choice of making the conversion at that stage or later, on a 16-bit TIFF. There is plenty of conflicting advice on the workflow sequence, but in reality, there are no truly compelling reasons for doing any particular procedure first, or last, or wherever. The purpose here is to present the basic procedures and show how you might consider sequencing them.

The underlying assumption here is that you are shooting Raw, which gives the maximum opportunity for controlled processing. Not the least advantage is that there is some latitude to adjust the actual exposure. This is because of the extra dynamic range offered by the higher bit depth of 12-bit and 14-bit capture in

a good DSLR. The amount you can adjust by depends on the sensor, the subject and the original exposure settings, and is hardly ever up to the theoretical maximum of two stops up or down; however, you could normally expect a useful half to one stop range of adjustment. Note that this only applies to processing Raw images, not to JPEGs or TIFFs, which have already been processed in-camera and reduced to 8 bits.

You can distinguish between those processing procedures that always have to be considered for every image, and the special procedures that certain images might need to solve problems (such as over- or underexposure, brightness, contrast, and so on). Processing workflow also varies according to the way you shoot, and indeed what you shoot. At one end of the scale are photographers, artists or enthusiasts, who are prepared to spend an infinite amount of time on one special image; at the other are those who will regularly process dozens at a time.

Essential and optional steps

Basic processing decisions that need to be considered for any image:

- Adjust exposure if Raw; if necessary, set black and white points
- Decide contrast
- Set hue adjustment

Processing refinements either to taste or to help solve problems:

- Highlight recovery
- Shadow lightening
- Local contrast tone mapping
- Toning/split toning

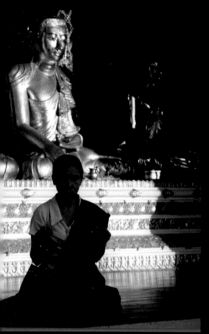

RAW GRAYSCALE CONVERSION OPTIONS

☑ Convert to Grayscale

Grayscale Mix

Auto Default

Reds	+6
Oranges	−1
Yellows	−5
Greens	−16
Aquas	−22
Blues	−3
Purples	+8
Magentas	+8

PHOTOSHOP

Photoshop's Raw converter (ACR) offers a grayscale conversion that makes use of hue sliders. An alternative is to process in color at this stage, and convert later from the TIFF.

HSL / Color / B&W ▼

Black & White Mix

Red	−11
Orange	−20
Yellow	−24
Green	−28
Aqua	−18
Blue	+12
Purple	+17
Magenta	+4

Auto

LIGHTROOM

Adobe Lightroom uses the same Raw converter as Photoshop, but integrates it with all its other processing functions.

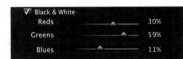

Black & White		
Reds		30%
Greens		59%
Blues		11%

Color		
Hue:		0.0
Sat:		-3.4
Lum:		-44.7
Range:		1.00
Hue:		0.0
Sat:		-3.4
Lum:		-44.7
Range:		1.00
Hue:		0.0
Sat:		-3.4
Lum:		-44.7
Range:		1.00
Hue:		0.0
Sat:		-3.4
Lum:		-44.7
Range:		1.00
Hue:		0.0
Sat:		-3.4
Lum:		-44.7
Range:		1.00
Hue:		0.0
Sat:		-3.4
Lum:		-44.7
Range:		1.00

APPLE APERTURE

On the surface, Aperture's Monochrome Mixer offers only a limited choice of hue adjustment, restricting the selection to percentages of red, green, and blue. This conversion works in a similar way to Photoshop's Channel Mixer, and acts like placing a colored filter on the lens. However, having made an initial black-and-white conversion, you can use the Color Brick to target and adjust specific tones.

NIKON'S CAPTURE NX

Nikon's Capture NX performs its hue adjustment by means of a hue selector along a scale, then strength, brightness, and contrast.

Black and White Conversion

Filter Hue			
0	360	60	°
Color Filter Strength			
0	100	40	%
Brightness			
-100	100	0	%
Contrast			
-100	100	0	%

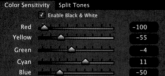

CAPTURE ONE

Capture One used to provide only a series of black-and-white preset profiles to choose from. More recent versions of the software, however, include a black-and-white conversion panel that allows you to adjust six specific color tones.

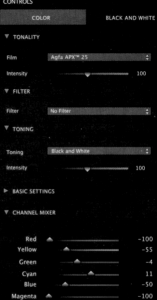

DXO

DxO FilmPack 3, like Capture One, offers both a number of presets—which in the case of FilmPack 3 are designed to replicate the look of 24 popular black-and-white films from the past—as well as six color controls to fine tune the monochrome conversion.

Silver Efex Pro

All processing software offers black-and-white conversion, but one plugin currently stands out for its devotion to mono and its powerful tools.

This is a rare case where I will devote these two pages to a specific program (other than the ubiquitous Photoshop). As a Lightroom, Aperture, or Photoshop plugin, it works after the Raw processing, and there is no disadvantage to this if the image has been saved as a subtly graded 16-bit TIFF.

In addition to the usual controls offered by all processing software, including hue adjustment, Silver Efex Pro has its own selective method as an alternative to emulations of traditional dodging and burning. Under their proprietary name U-Point Technology,

SILVER EFEX PRO

Nik's Silver Efex Pro features an attractive and intuitive interface. To the left of the large preview window is a strip of 38 presets arranged into categories: All, Modern, Classic, and Vintage. It's also a simple process to create or import your own personal presets using the buttons at the bottom of the preset panel. The preview window itself can be viewed in a variety of ways, including as a single view, split, or side-by-side. To the right of the preview is the main control panel. We'll look in more detail at the individual controls over the next page.

Preset Categories

All	Classic
Modern	Vintage
Favorites	

All Presets(38)

000 Neutral

001 Underexposed (EV-1)

All Presets(38)

000 Neutral

001 Underexposed (EV-1)

All Presets(38)

000 Neutral

001 Underexposed (EV-1)

PRESETS

Silver Efex Pro provides a good number of black and white presets, many of which are usable with little or no further adjustment required.

which this software developer first introduced in Capture NX, the official Nikon processor, this works as follows. You add a Control Point by clicking on an object or area that you want to adjust. This automatically reads Red, Green, and Blue values and location. Size can be increased or decreased to change the reach of the particular Control Point, and the three standard adjustments offered are Brightness, Contrast (both self-explanatory) and what the manufacturer calls Structure. Structure is this software application's term for a kind of local contrast control. While this is now a fairly common procedure—adjusting contrast on a relatively small scale by taking into account the local neighborhood of pixels—the algorithms for selecting the

area affected vary. Here, Nik Software has its own algorithm, which in the developer's words "increases/decreases the contrast inside an object without increasing the outside contrast (e.g. the structure of a tree but not the outline of the tree, which could cause a halo effect)."

Also notable is film emulation, which is more comprehensive than most in that the choices offer not just grain structure, but tonal response also, accompanied by characteristic curves. These were shown on pages 60–65. For followers of the Zone System (pages 166–71), there is a useful 11-zone scale below the magnifying loupe.

Recommended Workflow

Before you can edit your image, you need to launch it in Lightroom, Aperture or Photoshop, since it is a plugin. From then on, the software manufacturer's recommended workflow for best results is as follows.

2. Adjust the overall image brightness, contrast, and structure.

1. See if one of the presets in the Preset panel is appropriate.

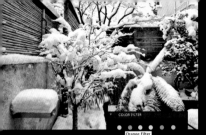

COLOR FILTER

Orange Filter

4. Choose a color filter for hue adjustment.

Agfa APX Pro 100

	Neutral
ISO 32	Kodak ISO 32 Panatomic X
ISO 50	Ilford PAN F Plus 50
ISO 100	Agfa APX Pro 100
	Fuji Neopan ACROS 100
	Ilford Delta 100 Pro
	Kodak 100 TMAX Pro
ISO 125	Ilford FP4 Plus 125
	Kodak Plus-X 125PX Pro
ISO 400	Agfa APX 400
	Ilford Delta 400 Pro
	Ilford HP5 Plus 400
	Ilford XP 2 Super 400
	Kodak 400 TMAX Pro
	Kodak BW 400CN Pro
	Kodak Tri-X 400TX Pro
ISO 1600	Fuji Neopan Pro 1600
ISO 3200	Ilford Delta 3200 Pro
	Kodak P3200 TMAX Pro

5. Choose a film type preset if desired.

FINISHING ADJUSTMENTS

▶ Toning

Strength 0 %

Silver Hue 30 °

Silver Toning 0 %

Balance 0 %

Paper Hue 56 °

Paper Toning 0 %

▶ Toning Off

Amount 0 %

Circle Rectangle

Size 50 %

Place Center

▶ Burn Edges Off

Amount 0 %

Size 0 %

Transition 0 %

Place Center

▶ Image Borders Off

6. Use the Finishing Adjustments panel to apply a variety of effects, including vignettes, burned edges, and borders, as well as a good selection of preset tones, such as Cyanotype, Copper, and Selenium.

7. When you're happy with the preview, click Save in the bottom right-hand corner.

Basic Processing

The increasing sophistication of Raw converters, with more controls and special algorithms being added, can easily obscure the basic principles.

We can do more to bring out the best in the original capture than ever before, and that can only be good news; but faced with perhaps a dozen sliders, each of which will have an impact on the others, where do you begin? Ultimately, the solution is to spend more time learning what all the controls do and what effects you can see from them, but you can make a very effective start by thinking clearly about the priorities. There have always been a few basic principles in optimizing an image, back to the days of wet film processing and printing. While the names of these may have changed, the core needs remain the same.

Optimizing in Lightroom

Make sure that the shadow and highlight clipping warnings are activated. Then do the following:

1. Set mid-tones using the Exposure slider. Don't worry if highlights or shadows clip at this stage.

2. Adjust Contrast to personal preference.

3. Use Highlights and Shadows sliders to bring back detail in the shadows and highlights regions. By this stage, most clipped regions should be fixed.

4. If necessary fine tune the black and white points using the Whites and Blacks sliders.

5. Go back to any of the sliders to finalize the image.

This shot of a Zen Garden exhibits strong contrast between the covered section and that open to the sky.

Midtones were set using the Exposure slider, resulting in blown highlights.

Reduced to the simplest level, there are just three basic image qualities for a monochrome photography: brightness, contrast, and tonal range. When you shoot, unless you exercise some kind of external control over the scene (by lighting it, or using a reflector), you can influence just the first of these, by choosing the exposure settings. Contrast and tonal range depend on the scene. When it comes to processing, however, each of these is adjustable. They are also interdependent. Moving one can affect another, so that even if you argue that one of the three takes priority, in practice you may still need to return to it after adjusting the others. Nevertheless, in an attempt to keep a clear view, let's look at each of these basic adjustments alone. As we shall go on to see in the following pages, the order in which you tackle each of

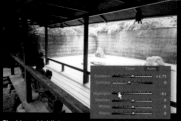

The blown highlights were recovered using the Highlights slider.

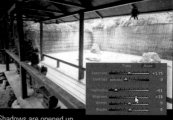

Shadows are opened up further using Shadows.

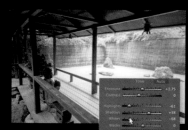

The brightest highlights are darkened using the Whites slider.

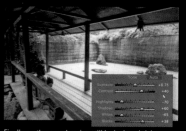

Finally, as the gravel region still looked too bright, the mid-tones were darkened with the Exposure slider, and the Shadows and Blacks sliders were increased to compensate. Adding Contrast gave the final image more punch.

the three key adjustments varies depending on whether you're working with a Raw or processed file. Note also that contrast is a term that has been, and continues to be, used in conflicting ways. In the days of film, it was customary to use it to refer to the dynamic range as well.

Tonal Range

Standard processing usually attempts to fit the tonal range of the image to the full scale available. This means, in effect, that the very darkest tones in the image are a fraction short of pure black, and the very lightest tones a fraction short of pure white. This is absolutely not compulsory, but the truth is that the majority of black-and-white photographs tend to look best like this.

The histogram is the key display, whether you are looking at it in a Raw converter (like ACR), or in Levels or in Curves with it superimposed. In the terminology of film and wet printing, when the tonal scale of the image just fits the scale of the histogram, you will have a fully scaled image. Now, if the scene you photograph just fits the range of the sensor, from dark to light, and if your exposure is accurate, then the tonal range should fit the histogram perfectly. If the scene is flatly lit, meaning that the dynamic range is less than that of the camera sensor, then the image as you captured it will be underscaled, and a candidate at least for expanding its range. More common, however, is a scene with a higher range than the sensor can cope with, so that the shadow end or the highlight end of the tonal range— or both—are squashed up against the ends

98

Optimizing in Photoshop

1. Drag the black-point Input slider on the left to the right as far as the first group of pixels in the histogram. To check for accuracy, hold down the ⌥ key (Mac) or Alt key (Windows) as well. With the black-point slider, the image will be pure white until you reach the first pixels; in other words, it will show at what point you clip the shadows. Now do the equivalent for the white-point slider on the right, dragging it to the left. Hold down the ⌥ key (Mac) or Alt key (Windows), and you will see white pixels appear out of black. The aim is to close in just up to the point of clipping.

2. Click the black-point dropper to activate it, then find the darkest shadow in the image and click on that. You can find the darkest shadow using one of these methods:

a. By first dragging the black-point slider with ⌥/ Alt key depressed as in step 1 (above).

b. Going to Curves and using the eyedropper on the image, while seeing where each tone is located on the curve.

c. Running any cursor across the image while seeing the results in the Info palette.

Do the equivalent with the white-point dropper.

3. Click Auto in the Levels dialog, or go to *Image > Adjustments > Auto Levels*.

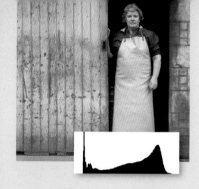

Here is the TIFF, not yet optimized, together with the histogram. Just a glance shows that there is room at both ends to close up.

Drag in the left slider, holding down the ⌥/Alt key to display shadow clipping. Go in until you just see clipping, then pull out until there is none.

The final black point setting.

Do the same at the highlight end; close in until the clipping warning appears, then pull out.

The final settings and image.

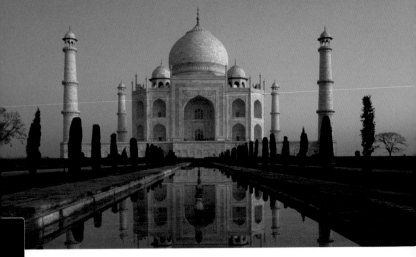

TAJ MAHAL
The starting image.

of the scale. The more serious problem is highlight clipping, which is why the safe exposure decision for most high-range subjects is to hold the highlights. Nevertheless, as the Raw example here shows, there is some extra exposure latitude that you can usually recover in the Raw converter.

Brightness

While there are real differences between luminance, luminous intensity, brightness and lightness, from the point of view of what looks satisfactory they are, frankly, academic. For appearance, which is what most photographers are concerned with, brightness is a perfectly adequate term. It is, indeed, not precisely measurable, because it is perceived luminance.

With an already-processed image, altering brightness is a matter of dragging

the values higher or lower, typically using a slider, or by dragging a control point on a curve. There are several ways of doing this, depending on the processing software, but what they all have in common is that they affect the values within the tonal range, and leave the end points alone. This is why traditional digital procedure is to set the black and white points first, then work on the overall brightness. The situation became rather more complicated with Raw converters, because of the possibility to adjust the exposure itself. As explained earlier, if your camera sensor captures in 12 bit or 14 bit, and your final destination is an 8-bit image, then potentially you have some exposure room for maneuver.

Exposure vs. Brightness

In some Raw converters, altering the exposure is very close to changing the exposure settings at the time of shooting, and so will clip highlights if raised high enough (and shadow clipping also in the opposite direction). The Brightness slider, on the other hand, works within the upper and lower limits, and so avoids, for the most part, clipping.

However, more recent versions of Lightroom (4 and beyond) utilize the new PV 2012 adaptive processing algorithm and have dispensed with the Brightness slider, with the new Exposure control leaving the black and white points more or less untouched. If highlights or shadows do become clipped, these are now recovered using the Highlights or Whites, sliders or the Shadows and Blacks sliders, respectively.

STEP 2
Enhance this selection by increasing contrast.

ORIGINAL IMAGE
In Photoshop, clicking on this small icon in the Channels palette automatically selects the lighter 50% of tones.

Contrast

Contrast has become less easy to define since the invention of processing algorithms that work locally, meaning within a small area. Also, it was regularly misused in the days of film to take in the total dynamic range. One thing that digital processing has forced is a more accurate way of thinking about image qualities such as contrast. So, if you look at an image as a whole, its contrast is the ratio between the darkest tones and the brightest. But not necessarily the very darkest and brightest, however, as these may simply be outliers that sit apart, such as tiny specular highlights.

The traditional way of manipulating contrast is with a curve. Take one point in the upper part and drag it brighter, then a second point in the lower part and drag it in the opposite direction, and you have a classic S-curve and an increase in the overall contrast. The reverse—lowering the value of the brighter parts and raising those of the shadows—gives you a lower contrast.

However, contrast no longer needs to be applied globally. You might, for example, have an image which is well separated spatially into two areas, darker and lighter, as in the example of the woman in a doorway here. What if you preferred to adjust the contrast of each of these differently? A straightforward manual way would be to make a selection of each area, and then apply a contrast-enhancing S-curve to one area, and a contrast-reducing reverse S-curve to the other.

Simpler still is using one of the several local contrast tone-mapping algorithms that work by searching around each pixel to look at its neighbors, and so do a similar thing, adjusting the contrast in a local area. Photoshop's Shadows/Highlights was one of the first of these (*Image > Adjustments > Shadows/Highlights...*).

Select | Filter | Analysis | 3D

All	⌘A
Deselect	⌘D
Reselect	⇧⌘D
Inverse	⇧⌘I
All Layers	⌥⌘A
Deselect Layers	
Similar Layers	
Color Range…	
Refine Edge…	⌥
Modify	▶
Grow	
Similar	
Transform Selection	
Edit in Quick Mask Mod	
Load Selection…	
Save Selection…	

STEP 3

Lower the contrast in the lighter tones with a curve.

STEP 4

Invert the selection to select the darker tones.

STEP 5

Raise the contrast in these darker tones with a curve.

Shadows/Highlights

Shadows
Vibrance — 15%
Saturation — 33%
Radius — 200px

Highlights
Amount — 10%
Tonal Width — 20%
Radius — 30px

Adjustments
Color Correction — +20
Midtone Contrast — +20

Black Clip — 0.01%

ALTERNATIVE

Instead of all the steps, use the Shadows/Highlights adjustment to achieve a similar result.

Colors into Tones

Possibly the greatest leap in creative potential that digital has brought to black and white is total control over how each individual color reproduces.

You want that red to be lighter, or that green darker? Well, you can have both at the same time if you want. Or any other color darker or lighter. This is the extent of post-production possibility with digital shooting. The principle is not new—serious landscape photographers using film, for instance, have made use of colored filters for decades in order to darken skies, lighten vegetation and more. What is new, however, is the ability to be completely precise, and to do it in post-production so that you can see exactly what the effect will be on screen, without losing the color the original either.

Two things come into play here. One is the sensitivity of our eyes to different wavelengths—or colors, as we call them—and the other is the relative brightness of different hues. These two factors come together to create a scale of brightness-by-color that seems natural to us. We think of yellow as bright and purple as dark, by default. The human eye sees color because

its cone receptors come in three varieties: red-sensitive, green-sensitive, and blue-sensitive (it is the absence of one of these that leads to color blindness). When added together, the total sensitivity peaks in the middle, which is yellow-green. The result is that we see colors as having different values. German poet and playwright J.W. von Goethe who attempted to put a measure to this, and suggested the following relative values: yellow 9, orange 8, red and green 6, blue 4, and violet 3.

In other words, shooting in black and white involves an expectation of how colors should reproduce as a plain tone. We expect a clear blue sky to be fairly dark, we expect Caucasian skin to look pale, green leaves and grass to look fairly light, and so on. None of this is precise, but we sense when the tones appear not quite right. The blue-sensitive and orthochromatic films in the early days of photography characteristically produced images in which blue skies appeared white and Caucasian skin tones too dark. The development of panchromatic film was aimed at "correcting" just this unexpected result that the eye and mind intuitively found "wrong."

COLOR PROPORTIONS
The proportions of primary and secondary colors that conform to our normal perception, balancing stronger against weaker values.

Orange / Blue Orange / Green / Violet

JIA NAI YUN
The original color image, in which the only distinct color is the red of the pomegranate.

DESATURATED
Straight desaturation is applied across the board, equal for all channels.

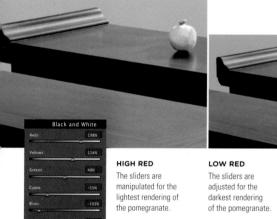

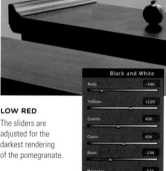

Black and White	
Reds:	198%
Yellows:	114%
Greens:	40%
Cyans:	-55%
Blues:	-105%
Magentas:	19%

Black and White	
Reds:	-49%
Yellows:	122%
Greens:	40%
Cyans:	60%
Blues:	-29%
Magentas:	-55%

HIGH RED
The sliders are manipulated for the lightest rendering of the pomegranate.

LOW RED
The sliders are adjusted for the darkest rendering of the pomegranate.

Red / Green

Yellow / Purple

Yellow / Red / Blue

Default Conversions

Every digital image-processing software offers a simple, no-thought, single-click method of turning a color image into monochrome. Some offer more than one.

What is important to realize is that every one of these involves a decision as to how to do it. There is no such thing as a standard, "correct" method. Even the seemingly most innocuous and decision free, which is desaturating each channel, tacitly assumes that treating each channel equally is somehow even-handed. Now that channel mixing is widely available, and we will come to that on the following pages, it should be clear to everyone that there is an open choice of how bright or dark different colors will translate to monochrome. With this in mind, the best ways to use your software's default conversion are as a quick preview and/or as a reference point against which to start channel mixing.

Here, for comparison, are a variety of defaults offered by different processing software. Note also that some offer presets with a bias toward certain effects, such as lighter, darker, higher contrast.

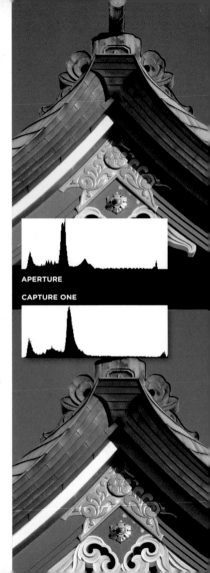

APERTURE

CAPTURE ONE

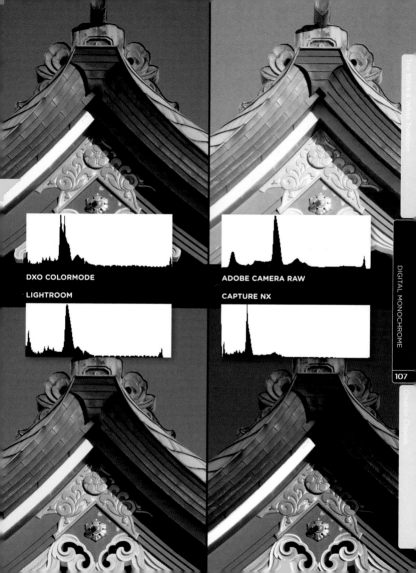

DXO COLORMODE

ADOBE CAMERA RAW

LIGHTROOM

CAPTURE NX

Hue Adjustment

Things have come a long way since the introduction of the Channel Mixer, which was basically a one-stop dialog window for adjusting the relative strengths of grayscale conversion for each of the three channels: red, green, and blue.

Although the Channel Mixer persisted into Photoshop CS3, it was made largely redundant by the Black and White dialog, which expanded the number of channels available for adjustment to include cyan, yellow, and magenta. Also, for anyone shooting Raw, this hue adjustment was available within the Raw converter. Now hue adjustment can be made for eight hues, either in the Raw converter, or later in post-production. The color spectrum is divided into Reds, Oranges, Yellows, Greens, Aquas, Blues, Purples, and Magentas, which should be enough to satisfy most monochrome photographers.

In truth, there are several ways of adjusting hues while converting to grayscale. Some predate the simple all-in-one Photoshop method, and involve copying channels into layers, then blending those. Using layer masks and adjustment layers increases the options, and also the complications. There are a few examples here of do-it-yourself hue adjustment and channel mixing to give you a sense of the range of techniques, but frankly, if you are working within Photoshop, its eight-hue slider approach is all most people could ask for. Other processing software offers similar choices, though packaged in a different way.

COLOR ORIGINAL
The color original of a Spanish Colonial cathedral.

BLACK AND WHITE
Photoshop's Black and White default settings.

YELLOW
Yellow Filter preset.

Reversals of Brightness

As a demonstration of how powerful hue adjustment can be, if you have an image with definite and contrasting colors, it's possible to prepare two opposite interpretations of tone.

Usually, the aim of hue adjustment is to produce a monochrome version that more-or-less equates with the original color image. But this is not a rule, and one of the reasons for going monochrome is to have greater freedom of expression.

Obviously, when the original colors are strong and pure, they react the most to hue adjustment, so for this example we'll take a striking contrast—a freshly painted Parisian mailbox. For the human eye and brain, yellow is always bright, never dark (darken it and it becomes a different color to our senses: ochre). So the natural expectations for converting this image would be a bright yellow and a medium-dark blue.

What happens with a neutral, unadjusted conversion? Two things. A disappointing lack of contrast, nothing like that experienced in the color image, and the yellow darker than we would expect. If you came across the monochrome version with no reference to the color original, few people would imagine that the main color had been yellow. Before moving on to a high-contrast version, let's prepare by finding the settings that will come as close as possible to making the yellow and the blue equal in tone. As these colors are quite pure, and the hue sliders are sharp-cut, it turns out that adjusting the blue alone does the trick.

Now for a conversion that maximizes the difference, with yellow as bright as possible.

With this simple image, we need only the yellow and blue sliders, and neither affects the other. First, we raise the yellow tone. A level of 100 is as bright as we can get without clipping highlights, but this is a good perceptual match for a strong yellow. Second, we take the blue down. How much is a matter of taste. Note that the arrow and lettering have more cyan in them, and so they remain readable.

Next, the reverse. Interestingly, we don't need to lower the yellow slider very much before the tone goes dark. Raising the blue is next, but in order to retain some legibility in the lettering, the cyan slider also needs to be adjusted. Juggling the blue and cyan sliders together took a few tries.

PARIS MAILBOX
The color original.

BLACK-AND-WHITE TOOL VARIATIONS

NEUTRAL CONVERSION

A neutral conversion, the equivalent of desaturation, has all the sliders at their midpoint.

EQUAL TONE

Adjustments used to get as close as possible to matching the two tones.

MAXIMUM YELLOW

The maximum reasonable contrast with bright yellow.

MINIMUM YELLOW

The maximum reasonable reverse contrast.

Using Hue to Control Contrast

The traditional way to adjust contrast in an image is to drag the lighter values one way and the darker values in the opposite direction.

A subtler and more satisfying method is to take advantage of the contrast of color within the original scene. If there are two important colors in an image that are in opposition, such as red and green, or blue and yellow, then adjusting the hues in the conversion to monochrome will easily do the trick. Raise or lower the tonal value of one color, and its opposing color will naturally go in the opposite direction.

There are some obvious, but very specific examples, such as an orange photographed against a blue sky, or a tomato resting on green lettuce. These depend on the precise scene, and the example here shows what can be done. Taking careful decisions in the hue adjustment can make it unnecessary to deal with contrast later in the traditional way. Even more to the point, this

technique becomes particularly useful in outdoor photography in situations where there is a color contrast in natural lighting. The classic case is clear weather and bright sunlight. Without haze there to soften the effects, anything exposed to direct midday sunlight will be lit by "white" light (around 5000-5500K), but anything in shadow will be lit by a much bluer light coming from the sky, at anything from, say, 7000 to 10000K). Now, the sky and shadows will respond precisely and obviously to either the blue slider or its opposite, which is a combination of red and yellow. Increasing red and yellow, and/or decreasing blue, will not just darken sky and shadow, but also raise the overall contrast, seemingly changing the weather. Do the opposite and you will reduce the contrast. The maximum conditions for this are a clear atmosphere, high altitude, and a low sun (which has a lower color temperature and so a redder light). The minimum conditions are haze and overcast.

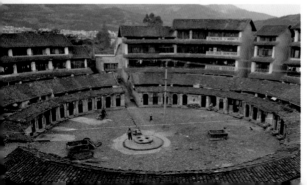

JUENING TULOU
Color original. The mild contrast of cool, bluish hues and warm, orange ones can be exploited to enhance the contrast in the conversion to black-and-white.

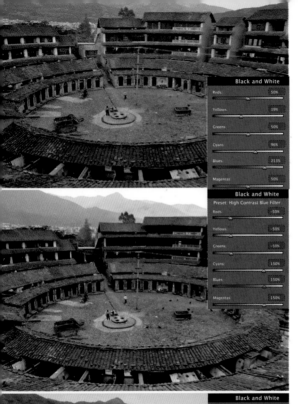

VARIATIONS

DESATURATION

A straight desaturation reproduces the original contrast quite faithfully.

HIGH CONTRAST BLUE

One of the Photoshop Black-and-White conversion presets is High Contrast Blue, which raises the values of the cooler hues and lowers the warmer ones.

HIGH CONTRAST RED

Also increasing the contrast, though not by quite as much, is the preset High Contrast Red, which raises the warmer hues and lowers the cooler ones.

Using Hue for Depth & Atmosphere

One of the most valuable hue controls in black-and-white photography is altering the sense of depth in a landscape shot. The technique, as old as panchromatic film, relies on passing or blocking blue, which increases with depth of atmosphere.

The reason the blue hue is blocked is the selective scattering of light by the atmosphere; as the bluer wavelengths are shorter, they get scattered more easily by particles in the atmosphere, and so are more visible.

There are two ways to go: compressing aerial perspective by darkening the blues and so clarifying distant parts of the scene,;and expanding it by lightening the blues to give a greater sense of depth. The traditional filter way was to use a red filter for the first (or orange, or even yellow for a milder effect), and a blue filter for the second. The digital version follows the same principle, but offers more control and, more importantly still, the chance to decide which route to take later during processing.

Given choice, most people seem to have a natural reaction toward heightening contrast, probably because it has the effect of making images appear clearer, even sharper. Of course, this can be valuable and effective when converting to black and white, but it would be a mistake to treat it as a default. Going in the opposite direction—expanding the aerial perspective—can also expand the sense of scale in a landscape, and is generally a more delicate result. We can compare the two alternatives in two different landscapes here.

The first, on the opposite page, is a sunrise view over the ancient city and ruins of Pagan in central Burma—actually taken from a balloon. I've chosen this because of the distinct blue that suffuses the atmosphere and it includes wraiths of morning mist hanging between the trees. This, coupled with the reddish brickwork and gold leaf of the temples, is a color contrast that will certainly respond strongly to hue adjustment. But a point to note is that most landscapes are not by nature super-saturated, and if they have a significant amount of vegetation, the colors can be complex. Greens in particular are very rarely a rich green, and can contain yellows and even reds. When doing this kind of atmosphere control, vegetation greens are often the joker in the pack and need to be watched carefully. We'll see more on this in a few pages when we look mainly at vegetation.

The first version aims to remove any sense of mist and haze, and the starting point is the High Contrast Red preset in Photoshop's Black and White conversion tool. From this, the red slider is taken up even further until just before the lightest reddish hues would clip to pure white. The result is a quite spectacular clarification, with almost no trace of the morning mist left, and high visibility all the way to the distant hills. Whether it is successful or not, however, is open to question. The opposite direction aims to enhance mist and haze, so the blue slider is the first control to use. The limit for its final setting is the reaction of the sky in the upper-middle section of the frame—this needs

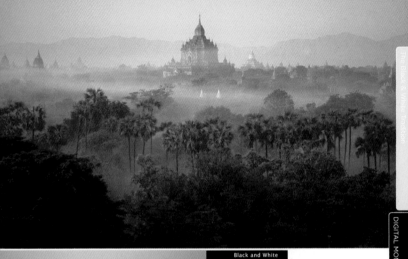

Black and White

Reds:	187%
Yellows:	120%
Greens:	-10%
Cyans:	-50%
Blues:	-68%
Magentas:	120%

VARIATIONS
Top to bottom:

ORIGINAL
Color original, with early morning shade adding blue to the atmosphere and the mist.

Black and White

Reds:	16%
Yellows:	43%
Greens:	73%
Cyans:	58%
Blues:	127%
Magentas:	90%

HIGH CONTRAST RED
Photoshop's preset High Contrast Red, adjusted to further lighten the red response.

BLUE PLUS
Custom settings to lighten the blue, while integrating the varying shades of green in the trees.

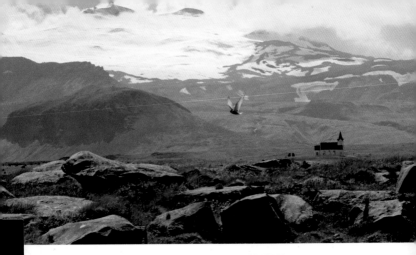

COLOR ORIGINAL

to be held below clipped pure white. Next, the red and yellow sliders are adjusted downwards to increase the silhouette effect of the temple, particularly the largest, by darkening them. The treetops in the lower half of the frame are a little problematical, because they contain cyan and some blue. Plenty of control is available, but the final settings were chosen to fade the tones of the trees from dark in the left foreground to mid-gray in the middle distance.

The second image is lower in color saturation, but covers a depth of a few miles and has mountains in the distance that make a substantial part of the scene. In both versions, handling the whites of the clouds and snow was crucial, and the danger of clipping set limits to a number of the sliders. As a reference, I first made a default desaturation result, which already shows an expansion of aerial perspective.

For the compressed landscape version, blue and cyan were taken far down (the image is much less saturated than the previous example from Burma, and so the hue response more sluggish). Also, I decided it would be more effective if the tone of the grass was raised to match the distant hill-slope tones, so that there was no shading of tone from foreground to background. The effect has punch, although the hovering tern in the near-middle distance does not stand out particularly well.

Moving on to the opposite version, there is not a great deal to do to improve on the default desaturated result. Lowering the blue, however, removes the shading in the cliffs on the left and lowers the contrast overall on the hills, thus flattening the distance. The blue sky is also rendered a little paler. Finally, to enhance the foreground-to-background transition, I darkened the grass.

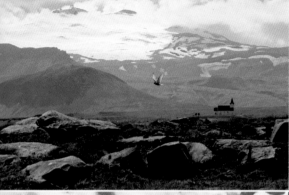

BLACK-AND-WHITE VARIATIONS

DESATURATION
A straight desaturation made for reference.

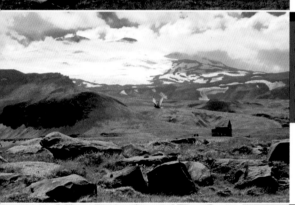

Black and White	
Reds:	162%
Yellows:	153%
Greens:	200%
Cyans:	-118%
Blues:	-148%
Magentas:	50%

COMPRESS ATMOSPHERE
Depth is compressed by lowering blue and cyan strongly, and raising red.

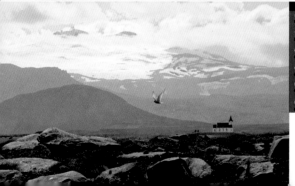

Black and White	
Reds:	107%
Yellows:	34%
Greens:	77%
Cyans:	192%
Blues:	120%
Magentas:	80%

EXPAND ATMOSPHERE
Depth is expanded by raising blue and cyan.

Using Hue for Vegetation

Using a Hue adjustment to control the tones of vegetation is not as straightforward as dealing with skies and depth in landscapes.

One reason it's so difficult to balance hue adjustment when shooting plant life is that vegetation greens are usually anything but saturated, and include yellows and sometimes even reds. Also, a variety of vegetation can involve different hues and different overall tones. Usually, an amount of juggling and trial and error is involved. To focus on the niceties of green hues and tones, I've chosen a single picture to work on. As a first step, let's see what a default desaturation looks like. Not at all successful; the trees are darker than the eye expects them to be, and show none of the separation from the rest of the scene that they do in color. What we should aim for is a lighter rendering, keeping contrast with the other elements in the picture. The first version uses the green slider alone to lighten the foliage, while moderate reductions to red, cyan, and blue darken the pagoda in the distance. This is only moderately successful, as the foliage and pagoda are too similar in tone.

Let's see how far we can lighten the greens. This particular green carries a high proportion of yellow, so by concentrating on the yellow slider to achieve the desired lightening, we not only get a lighter result overall on the foliage, but we also now have a valuable contrast of shading within the greens. To accentuate the contrast with the pagoda, cyan and blue are taken to their minimum. Compare this with Photoshop's Infrared preset. This too relies on lightening the greens and yellows (to mimic the response of chlorophyll to infrared), but is more exaggerated.

Finally, having seen that varying the yellow and green sliders can increase contrast within the foliage, let's see how far this "internal" contrast can be taken. Striking, certainly, but a little odd. All in all, the second version is the most successful.

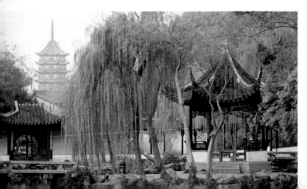

THE COLOR ORIGINAL

In the original the green weeping willows stand out clearly, while the other leaves have more mixed tones.

VARIATIONS

DEFAULT

The desaturated result has the leaves too dark, and the trees merge with everything else.

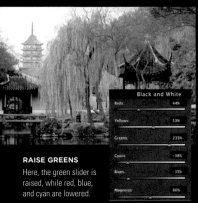

Black and White	
Reds:	44%
Yellows:	53%
Greens:	235%
Cyans:	–38%
Blues:	–35%
Magentas:	80%

RAISE GREENS

Here, the green slider is raised, while red, blue, and cyan are lowered.

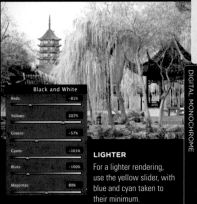

Black and White	
Reds:	–81%
Yellows:	207%
Greens:	–57%
Cyans:	–101%
Blues:	–106%
Magentas:	80%

LIGHTER

For a lighter rendering, use the yellow slider, with blue and cyan taken to their minimum.

Black and White	
Reds:	–40%
Yellows:	235%
Greens:	144%
Cyans:	–68%
Blues:	–3%
Magentas:	–107%

SIMULATED INFRARED

Photoshop's preset "Infrared" conversion.

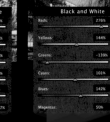

Black and White	
Reds:	276%
Yellows:	144%
Greens:	–139%
Cyans:	101%
Blues:	142%
Magentas:	50%

CONTRASTY

As an experiment, maximum contrast is set within the greens

Skin Tones

When most people refer to skin tones, they mean the shades of color. Here we're being literal—the actual tonal value, the brightness of skin when the image is converted to monochrome.

Skin colors are among the strongest "memory colors," meaning that we are so familiar with and sensitive to the way they should appear that the "correct" appearance in a photograph is embedded in our memory. Even without necessarily being able to identify in which way the balance is skewed, most of us can immediately sense whether or not skin color in an image looks correct. The same thing happens with a black-and-white image. If we know the person, or at least have an idea of where they come from, we have a feeling for the "right" tonal value.

This, of course, varies greatly with ethnic group, and is not simply to do with darker versus lighter, but also involves the general color cast. As distinct examples,

think of what we call rosy cheeks, or an olive complexion. Color complicates the conversion to monochrome, because of the huge choice in hue adjustment. Here, it will pay to take a more analytical approach to the image, and before making the conversion from an already processed TIFF, I want to measure the individual colors and the average brightness. Let's take three contrasting examples of skin: one white, another brown, the third black. The original three images were processed with very little alteration to the overall exposure and brightness. To all intents and purposes they are as shot, meaning that they closely resemble the original impression (confirmed by the camera's LCD preview at the time). This is important for this exercise as we need to take these originals as a reliable starting point. Also important is that I chose all three for being taken under cloudy diffused light, which has a reliable color temperature.

DIFFERENT TONES

In a world with a wealth of different skin tones, it is important to know how to handle each one.

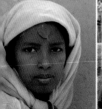

CAUCASIAN SKIN

This is very much at the pale end of the scale. The red square is the sample area, taken in Photoshop using an 11×11 pixel average. We're taking the sample from the forehead, which has no shadows across it. The Info palette has been set to show RGB readings in the first column and HSB in the second, and from the latter we can see that the overall brightness is high at 92%. Also, while you would expect white skin to have an overall pinkish cast, this has only a very mild bias. The conversion is neutral, using desaturation rather than a mix of hue sliders. The result is as most people would expect, and the conversion uncomplicated.

However, as an experiment, see what visual difference there is from just a small change of overall brightness. Here, I've selected just expect the face by painting a mask over it to make a selection. What is interesting is that just the small reduction of 15% gives the impression of a slight tan, while the same small increase verges on high-key. But ultimately, the "right" value is a matter of taste.

| Color R: 234 G: 218 B: 220 | Desat | -15 | +15 |

CAUCASIAN SKIN COLOR TO BLACK AND WHITE

Pale Caucasian skin shows a hint of pink. The bar above is the same color and brightness as the sample area in the red box.

CAUCASIAN SKIN
Default conversion using desaturation.

-15
The face only—not the background—has been darkened very slightly by 15%.

+15
The face only, has been lightened by 15%.

BROWN SKIN

The girl shown here is from Eritrea. Disregarding the leaf that she has stuck on her forehead (it is reputed to have healing properties), we take the sample from close by. This is directly comparable with the Caucasian-skin sample, but what a difference. The brightness is below average at 44% (though it would be higher from the cheeks), and red figures strongly. Note also the low blue value, which helps desaturate the overall color to brown. The monochrome conversion is again a straight desaturation, and I've supplied the same variations as before—up 15% and down 15%. Here, in contrast to the Caucasian skin, there seems to be a more acceptable latitude because this mid-to-dark toned skin is not close to either brightness limit—there are no obvious benchmarks of tone by which to judge it. Now we could take a different approach to adjusting the brightness by manipulating the hue sliders, but for the purposes of comparison with the other two skin types, we'll leave that particular exercise for the example of the two windswept male faces on pages 124–125.

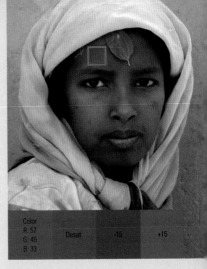

Color R: 57 G: 45 B: 33	Desat	-15	+15

BROWN SKIN COLOR TO BLACK AND WHITE

MEDIUM-TO-DARK BROWN SKIN

DEFAULT DESATURATION
Default conversion using desaturation.

-15
The face only, darkened by 15%.

+15
The face only, lightened by 15%.

BLACK AFRICAN SKIN

Here, there are actually huge differences in tone between ethnic groups, especially in southern Sudan where this photograph was taken. The ethnic group in this case is Dinka, whose skin is at the dark end of the scale. Now, one of the things that happens visually with pronounced black skin is that it reflects more than lighter skin, and the result is a higher contrast across the face. The forehead sample is somewhere in the middle of this range, and shows a brightness of 35%, but a second sample from a darker area on the cheek goes down to 22%. The full range goes from 60% at the tip of the nose to 10% in the under-chin area. The color is limited, actually with about the same difference between red, blue, and green as the pale Caucasian skin, although slightly more saturated in the darker non-light-reflecting areas. The brightness variations are perceptually less different than the other two examples, and one of the lessons here is that there is less latitude in interpretation of tonal value with pale skin than with dark.

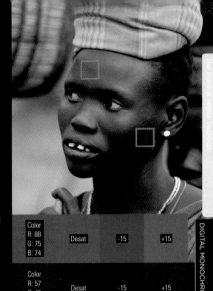

Color R: 88 G: 75 B: 74	Desat	-15	+15
Color R: 57 G: 45 B: 33	Desat	-15	+15

BLACK AFRICAN SKIN COLOR TO BLACK AND WHITE

DARK SKIN
Showing highlight reflections.

DEFAULT DESATURATION
Default conversion using desaturation.

-15
The face only, darkened by 15%.

+15
The face only, lightened by 15%.

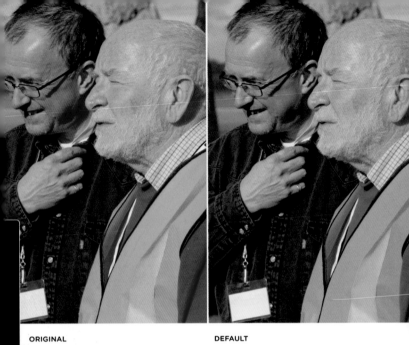

ORIGINAL
Two faces show a relatively strong red component.

DEFAULT
Default conversion using desaturation.

USING HUE ADJUSTMENT FOR DIFFERENT EFFECTS

These two faces are Caucasian, but windswept (the two men are archaeologists, so are out in the open air a great deal). These conditions give a strong red component, and we can use it to make quite subtle changes to the monochrome tone. With a straight desaturation for comparison (with the reddish areas of the faces typically a little too dark in monochrome), there are two other versions, one raising the red channel, the other raising the yellow channel for lightening. While both have the same approximate effect, note that raising the red channel reduces the contrast across the faces in comparison to using the yellow channel: This can be useful for fine-tuning shading.

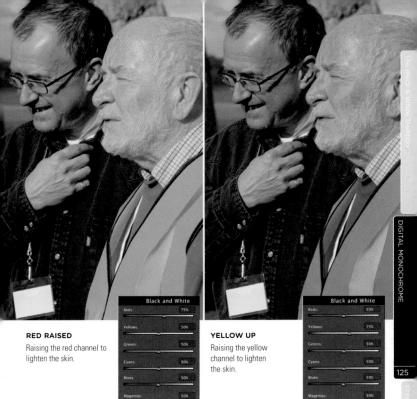

RED RAISED

Raising the red channel to lighten the skin.

Black and White

Reds:	75%
Yellows:	50%
Greens:	50%
Cyans:	50%
Blues:	50%
Magentas:	50%

YELLOW UP

Raising the yellow channel to lighten the skin.

Black and White

Reds:	50%
Yellows:	75%
Greens:	50%
Cyans:	50%
Blues:	50%
Magentas:	50%

Specific Colors

A different kind of approach is called for when there is one significant color in the scene.

Its importance can be due to all kinds of reasons, including the nature of the subject, the fall of lighting across the scene, or the special qualities of an uncommon color. The image I've chosen here is of lavender fields in Provence, in the south of France, and this annual crop is clearly the main subject of the shot—at least in the color version—despite the old abbey in the grounds where it grows.

The methodology for this kind of dominant-color image first involves deciding whether its importance as a color will even translate into monochrome; then deciding what sort of tonal relationship it should have with the other elements in the frame (the degree of contrast or similarity, and how eye-catching); and finally, the methods of isolating and altering that particular hue. In this shot, the special nature of the lavender hue becomes meaningless in black and white, but its growing in distinctive busy rows remains just as significant. In other words, it still warrants being the center of attention, but for its form and what it is rather than its color. It still needs to be an eye-catching part of the picture. The next decision is how to make it stand out, and the obvious aim is to have the lavender rows contrast with as many of the other elements as possible. We can reject making it darker, which would simply look weird.

The hue adjustments applied here are in several steps, but all with the aim of making the sunlit rows of lavender lighter

COLOR ORIGINAL
Lavender field in Provence, France.

than the surroundings (which includes the sky). This will draw maximum attention to them. The sky, in particular, will need to be dark, so as not to compete for the viewer's attention. As usual, my first step is to make a default conversion as a reference—a base against which to work. This default is the Photoshop version, slightly different from a straight desaturation. This is fine as far as it goes, but not if we want to favor the lavender as much as possible.

The first step is to isolate the lavender hue and lighten it. It is made up of blue, magenta, and red. At the same time, however, we want to do this without affecting the sky, which is blue. Now, the

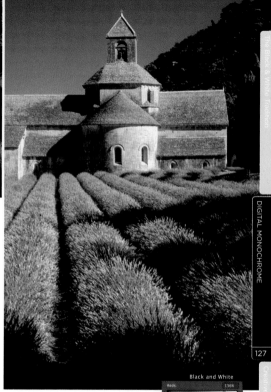

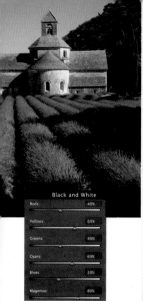

Black and White

Reds:	40%
Yellows:	60%
Greens:	40%
Cyans:	60%
Blues:	20%
Magentas:	80%

DEFAULT
Photoshop's default conversion.

sky contains some cyan and no magenta, so lowering the former to its minimum, and raising the latter to its maximum should give maximum contrast between lavender and sky. And it does. Raising red enhances this contrast. There is green mixed in with the purple of the lavender, so my decision here is to make it as light as the rest of the crop. Raising green does this, while lowering yellow evens out the lightness within the greens.

MAXIMUM LAVENDER
Adjustments to maximize contrast—with the lavender being light and all other elements looking as dark as possible.

Black and White

Reds:	136%
Yellows:	-62%
Greens:	185%
Cyans:	-200%
Blues:	43%
Magentas:	300%

Handling Opposites

Potentially, controlling the tonal behavior of opposing colors is the easiest of all.

Provided, of course, you want them to contrast with each other in the black-and-white version (lightening or darkening both together would involve merging two versions of the image). By opposing colors I mean complementaries, as already shown on pages 104–105, and these do not have to be so strong and saturated as the swatches there in order to react well to the hue sliders during conversion.

The example here is relatively unsaturated, but still distinct in the color contrast between the yellowish cheroots in a Burmese street stall and the blue shelves. The default conversion in fact does a good job of maintaining the color contrast and giving an expected result. Nevertheless, let's see what can be done to enhance the contrast. Here, the key light tone chosen is the front end of the largest bundle of cheroots, which I want as bright as possible

without appearing white. This means striking the right balance between red and yellow when raising those sliders, as both are part of the cheroot color. As for the painted shelves, lowering the blue is the obvious approach, but note that the sunlit parts contain more cyan. Here, the cyan has been reduced to remove them—not necessarily a good thing for the picture, but done here to show that it is possible.

Now, one of the features of opposing colors in an image is that it is nearly always possible to make a reverse contrast conversion—the contrary, that is, of what the eye expects to see. We already saw this in action on pages 110–111. Here, in more subdued color circumstances, it is still a valid possibility. Certainly, it looks strange and unexpected if you already know what the original colors were, but to a viewer coming to the monochrome image alone, it works. Still, between these three versions, the choice is down to taste.

COLOR ORIGINAL
Blue Burmese street stall.

DEFAULT

Photoshop default conversion (the settings are the same as those on page 127).

RED AND BLUE EMPHASIS COMPARISON

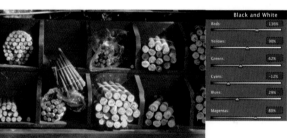

Black and White	
Reds:	136%
Yellows:	90%
Greens:	62%
Cyans:	-12%
Blues:	29%
Magentas:	80%

HIGH RED

Adjusted to exaggerate the color contrast, with the cheroots made lighter.

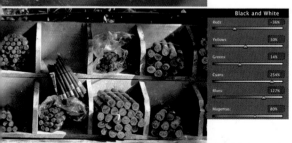

Black and White	
Reds:	-36%
Yellows:	30%
Greens:	14%
Cyans:	254%
Blues:	127%
Magentas:	80%

HIGH BLUE

The reverse adjustment, exaggerating the color contrast, but making the cheroots darker.

Handling Adjacents

When an image has groups of important colors that are similar to each other, but ones you want to separate tonally in the monochrome version, hue adjustment can be at its most delicate and demanding.

Changing one affects the others, so there are always compromises to be made, and the procedure calls for some fine distinctions to be made between component colors. In other words, do not expect a quick fix with images similar to the examples here and on the following pages.

The first example is an exercise in handling the warm sector of the color circle—reds, oranges, and yellows. The image features a table by designer Maarten Baas, with two gilded cups on it. While there is distinct red in the table and yellow in the gold cups, they both share orange. In fact, to some extent, they share all three hues available as sliders. As this will be a delicate operation, let's take color samples in the same way that we did for skin tones. This confirms that the yellow slider will be important in raising the value of the gold.

For a change, we will do the hue adjustment in Adobe Camera Raw (ACR)—the Photoshop Raw converter (previous conversions have been done on already-processed TIFFs). One good reason for this is that currently, ACR has an orange slider, which its Black and White converter does not. And we will need it.

To begin, the image is fairly accurately exposed and color balanced as shot, but we'll choose the standard Auto setting. Next, moving to the Grayscale window, we can take a judgment on the neutral default settings—as expected, but not enough tonal separation between cups and table. So, the next step is to darken the red of the table. Here, I'm cheating a little because I can guess in advance that the orange slider will be needed to lighten all except the gold highlights (which are strongly yellow), so we can take the red down a little darker than we will eventually want.

The next step is to raise the highlights on the gold cups, using the yellow slider. This affects hardly anything else. Finally, for the hue adjustment, the orange is raised; this lightens everything slightly and, more importantly, re-emphasizes the dappled reflections on the side of the table. As a last touch, once the image has been processed into a TIFF, the background is cleaned up by first selecting it using the Quick Selection tool, then applying a lightening curve.

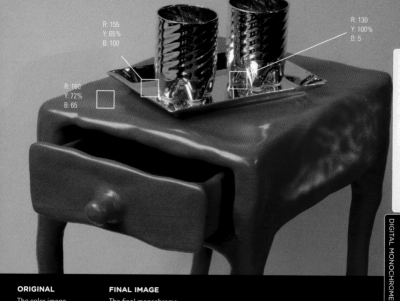

R: 155
Y: 65%
B: 100

R: 130
Y: 100%
B: 5

R: 160
Y: 72%
B: 65

ORIGINAL

The color image processed with default settings, and three sample areas analyzed.

FINAL IMAGE

The final monochrome result after ACR. (See pages 132–33 for step-by-step stages).

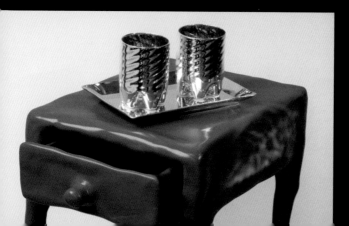

Camera Raw: Basic

White Balance	Custom
Temperature	3700
Tint	-7
	Auto Default
Exposure	0.00
Contrast	+45
Highlights	-21
Shadows	0
Whites	+55
Blacks	-2

HSL/Grayscale

Reds	0
Oranges	0
Yellows	0
Greens	0
Aquas	0
Blues	0
Purples	0
Magentas	0

HSL/Grayscale

Reds	-30
Oranges	0
Yellows	0
Greens	0
Aquas	0
Blues	0
Purples	0
Magentas	0

HSL/Grayscale	
Reds	-30
Oranges	0
Yellows	+79
Greens	0
Aquas	0
Blues	0
Purples	0
Magentas	0

STEP 4

Raising the yellow slider to lighten the highlights on the gold cups.

HSL/Grayscale	
Reds	-30
Oranges	+28
Yellows	+79
Greens	0
Aquas	0
Blues	0
Purples	0
Magentas	0

STEP 5

Raising the orange slider to lighten table and cups overall.

STEP 6

Having made a selection of the background with the Quick Selection Tool (note the compressed histogram, which is of the background only), a lightening curve is applied.

The Black & White Tradition

DIGITAL MONOCHROME

133

Creative Choices

Handling Adjacents

MEASUREMENTS

Samples of blue, cyan, and green extracted from five areas of the image.

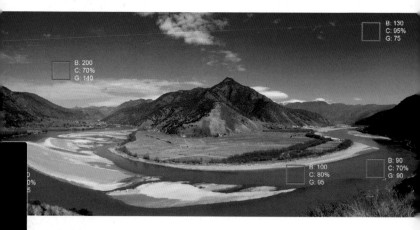

B: 200
C: 70%
G: 140

B: 130
C: 95%
G: 75

B: 100
C: 80%
G: 95

B: 90
C: 70%
G: 90

134

For the next example of an image with similar colors that need to be separated, I've chosen this panorama of the First Bend of the Yangtse River.

The sky is an intense blue, but shades in brightness toward the horizon, and the water contains a mixture of desaturated colors. The water, nevertheless, is one element that we might want to adjust for contrast. As with the previous image, we can start by analyzing the key colors. For this, the Info palette in Photoshop is useful, particularly if we open a second measurement in CMYK. This gives us a cyan measurement, even though the units are different from the RGB (percentage instead of levels from 0 to 255). Two sky samples show that cyan is relatively higher in the paler regions

(even though there is absolutely more, 70–90%) in the stronger, higher regions. There is also a strong cyan presence in the higher reflections of the sky in the river, meaning that the cyan slider will also affect these. Additionally, there is a strong presence of green in the water.

Blues and cyans both work to lighten the sky, but favoring the blue over the cyan evens out the sky overall, which can be useful here. See also the effect of the cyan on the reflections higher up in the water. The lower part of the river, closer to the bottom of the frame, contains green, and raising the green slider to the maximum lightens the river more, which relates to the light treatment of the sky. An alternative is to darken the green for a stronger contrast with the sandbanks—also valid.

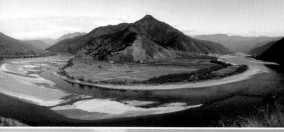

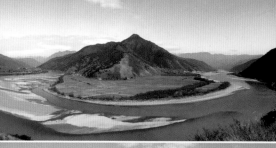

RAW CONVERSION
Top to bottom:

STEP 1
Raising blue and cyan together, but favoring blue, lightens and evens out the sky.

STEP 2
Raising green lightens the water.

STEP 3
Lowering green darkens the water for contrast with the sandbanks.

Handling Subtleties

The hue adjustment examples and issues that we've looked at so far have all involved colors that were either distinct, or at least obviously important to control in some way.

If you look back at many of the previous examples, they feature strong colors that can be interpreted in wholly different ways using relatively extreme adjustment slider settings. Many more picture situations, however, simply contain subtle colors that can be exploited to fine-tune the image. This could be an alternative or a complement to the usual tonal adjustments, such as applying

contrast curves and tweaking local contrast (for example, Photoshop's Shadows/Highlights method).

Here is just such an example, an image that relies on structure and form much more than color—hence the decision to render it in monochrome. The default conversion is perfectly acceptable, but it can still benefit from tweaking. One of the potentials in this image is the geometric pattern of highlights; the backlighting gives an edge not only to the wooden fencing

COLOR ORIGINAL
The original rural view.

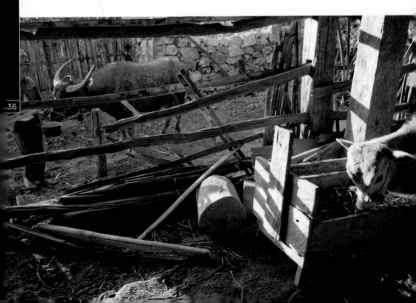

and structures, but also to the two animals and the farmer. A first step is to raise the yellow component in order to lighten the highlights on the wood and the calf—late in the afternoon, this light is warm. At the same time, the red is taken down to give a little separation in these highlights. The softer, bluer highlights on the buffalo and farmer (they reflect skylight) also give an opportunity to raise them, and relate them more closely to the other edge lighting.

Bringing all these edge lights together is the key to the processing of this image. Hue adjustment has gone some way toward this. What remains is to selectively increase

the contrast of the buffalo and farmer. As they are located in their own, separate region of the frame, a simple gradient selection (using the Quick Mask mode), makes it easy to apply an S-curve that increases their contrast and lightens them slightly. The effect is to make them more similar in tone and distinct from the more strongly lit foreground.

DEFAULT DESATURATION
A straight desaturation conversion for comparison. (See pages 138–39 for step-by-step stages to the final conversion)

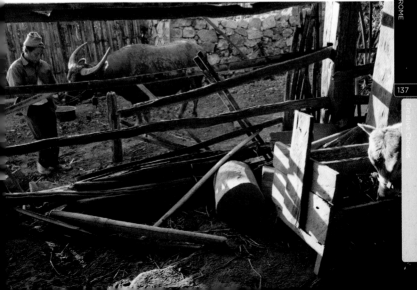

PROCESSING

STEP 1

Raising yellow and lowering red strengthens contrast on the parts of the wood that are directly lit and lit by reflection.

STEP 2

Raising blue and cyan lightens the soft edge lighting on the buffalo and man. For the sake of demonstration, it's shown here as a separate operation from the red and yellow adjustments.

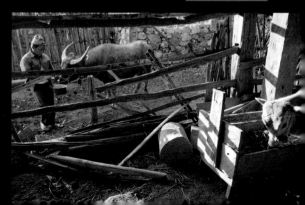

COMBINED ADJUSTMENTS

The two sets of adjustments shown together.

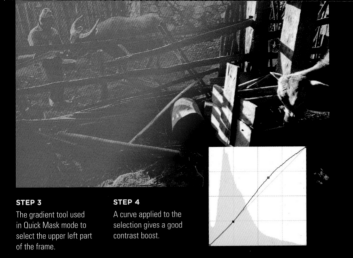

STEP 3

The gradient tool used in Quick Mask mode to select the upper left part of the frame.

STEP 4

A curve applied to the selection gives a good contrast boost.

FINAL RESULT WITH SELECTIVE CONTRAST

The final black-and-white result.

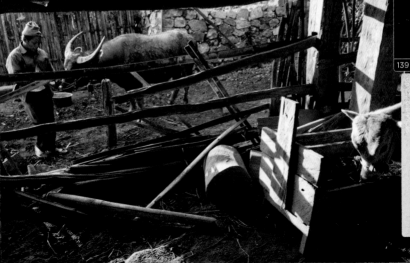

CREATIVE CHOICES

Possibly the greatest difference between photographing in color and photographing in black and white is in expression. There are, of course, all kinds of ways of treating color, made all the easier with the range of software processing available, but by far the most accepted standard is the aim for "realism."

Without getting philosophical about what realism means in the context of photography, the normal aims of most people's color photography are to get a result which in terms of image quality are faithful to the original scene. Black and white begins with quite a different premise, as we've seen. It does not, cannot, pretend to be "real," and the starting point is the individual photographer's idea of how a scene can look in shades of gray.

This might seem an obvious point to make, but it implies something important—all the choices about how to visualize a scene, shoot, and process are creative. This frees up a whole imaginative process, and you can choose to interpret an image in almost any manner. It could be somber, bright, airy, rich, delicate, soft, harsh, contrasty… the expression and treatment is almost infinitely variable.

Added to this, and stemming partly from it, is the fact that a black-and-white image can be treated to much greater extremes (such as in contrast and key) than a typical color image. As just one example of this, consider the usual processing limits for a color image, with highlight and shadow clipping being major considerations. Not slipping beyond the limits is fast becoming a rule, even an obsession, in digital processing. But try exceeding the highlight and shadow limits in black and white, as film photographers have done for decades (see the image by Bill Brandt in this chapter), and it will not necessarily look wrong. The latitude for creative expression, in other words, is built into black and white.

Thinking in Black & White

The Bayer filter, with its mosaic of green, red, and blue, preserves color information from the scene in front of the camera by separating it into three channels.

Nevertheless, underneath, the sensor itself is purely monochrome—it reacts only to the total quantity of multi-spectrum "white" light falling on it from different surfaces and light sources in the scene. This means that, unless you drastically and expensively remove the filter, you always have a color version of the view even if you are fully committed to creating black-and-white imagery.

The easiest approach to digital black-and-white, therefore, is to shoot first and later review the images to select those which might work better in monochrome. Absolutely nothing wrong with that, and for obvious reasons of illustration, many of the images in this book were chosen and processed in this kind of workflow. However, "full" B&W photography means anticipating, selecting, and composing monochrome right from the start. And the only way to do this is to train one's self to think and see in black and white. There are optical aids, as described here, but these are really tricks to fool the eye into ignoring the color in a scene for a short while. More effective long term is constant practice and experience in mentally filtering out color information.

This is not at all fanciful. For many years, serious photographers trained themselves to do just this. Edward Weston, as quoted earlier, was one of the generation of photographers who grew up shooting black and white, and so "spent years trying to avoid" the temptations of colorful scenes. To succeed in monochrome meant being able to see in advance what would work without color. Eliot Porter, who as we saw moved permanently from black-and-white to color without acquiring the dogmatism of the converted, said that "When Ansel Adams photographs something, he sees it as a black-and-white image right away and so he photographs it that way." That comes from years of training.

From the early and mid-twentieth century American school, artists like Sieglitz, Weston, and Adams took this further than the practical. Adams stressed the importance of visualization—deciding at the time of shooting how the final print should look. Adams reiterated Alfred Stieglitz's well-known dictum that the final image (always a monochrome print in those days) should reveal "what you saw and felt." "Once you admit your personal perception or emotional response," he wrote, "the image becomes something more than factual, and you are on the doorstep of an enlarged experience." All of this combined visualizing in black and white, with the emotional level of how the scene should feel.

A minority of photographers shifted at some point in their careers between black and white and color, among them notably Eliot Porter, Joel Meyerowitz, and Harry Callahan. As you will experience for yourself, moving from one camp to the other heightens awareness of the mental processes involved. Sometimes, it is easier

to define the skill of seeing in black and white in comparison to what goes on with color photography. Eliot Porter wrote: "I think it's entirely different from black and white. When photographing subjects like rocks, the approach is entirely different, because in black and white you see the forms much more than you do in color." Answering the question of how important it was to look for color rather than form, he replied, "You don't have to look for it—you see it. I see it as a color image right away—not always, because I still do some black and white. Some of the pictures I take in color could just as well have been done in black and white."

In their classic *A Concise History of Photography*, Helmut and Alison Gernsheim declared that, "Good color

MORNING SUN

Early morning sun just beginning to filter through fog creates an atmospheric distribution of tone that black and white helps emphasize.

photography demands more of the photographer than simply shooting with color film. Compared with black and white, color requires not only a different technique, but also a different way of seeing. In monochrome, the massing of light and shade, and the reproduction of texture are of the utmost importance."

The Range of Light: Adams & the Westons

There is a common aesthetic running through a great majority of Ansel Adams' prints.

It is apparent as a desire to capture the full range (Yosemite and the Range of Light, a mild pun, was indeed the title of one of his books) and a leaning toward drama, with rich blacks balanced against just-discernible high-value textures in snow, clouds, and the water spray.

Edward Weston, a friend of Adams who shared many of the same views about rich tonality and an "honesty" to both form and content, worked primarily with large negatives and contact printing. His best-known images span much the same full range as those of Adams, although the latter felt compelled to write that "Edward Weston's prints are much 'quieter' than many realize." They both agreed on the need to envision the print at the time of shooting, and that this final image—first in the mind, then on paper—should be personal to the photographer. As Weston put it, "the ultimate end, the print, is but a duplication of all that I saw and felt through my camera," although the word "but" is unduly modest. Brett, his son, continued in the same tradition, with perhaps even more emphasis on tonal drama, while never pushing the limits of full black and empty white.

MOON AND HALF DOME
Opposite: Ansel Adams

TONAL RANGE AND BIT DEPTH
Below: Digital sensors have gradually achieved the exposure range enjoyed by Adams' large-format film, but can still exhibit banding across large areas of smooth gradations, such as this sky.

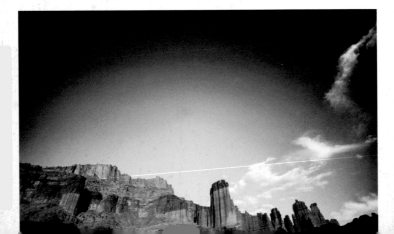

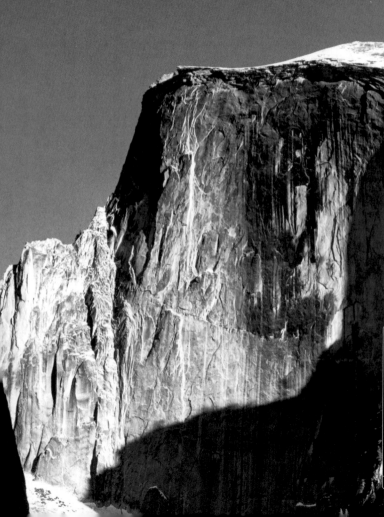

The Long Range of Gray: Paul Strand

While in no way suggesting that Adams and Weston paid any less attention to the central mid-tones than to the ends of the range, other photographer-printers dwelled much more on the grays, from dark gray to light gray.

This reflected both their preferred subject matter and an aesthetic in which subtle nuances between gray tones, well distinguished from one another, were highly regarded. One of the exemplars of this approach, at least for the majority of his long career, was Paul Strand—one of the twentieth century's most famous and best recognized photographers. Strand's work covers 60 years, from 1914 until his death in 1976. He made all his own prints until the very end, when he took an assistant to work under his guidance.

Unexpectedly, two of Strand's best-known images, *Wall Street* from 1915 and *White Fence* from 1916, are full of strong contrasts and are not at all typical of the bulk of his prints. He drew back from this dramatic approach, and his many portraits have almost all the attention concentrated in the middle range. The skin tones of his subjects are noticeably well modulated. The reason for this change is linked to the materials he used, for Strand began with platinum printing, as did many photographers of his generation. The tonal quality of a platinum print is so different from the silver bromide printing that succeeded it and which became the known standard for black and white, that it represented almost a unique medium in its own right. Dating back to the 1830s, platinotypes, as they are also called, have a deposit of platinum that sits mainly on

PAUL STRAND: *THE FAMILY*, LUZZARA, ITALY 1953

146

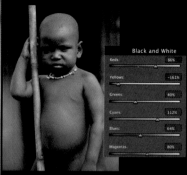

REDUCING CONTRAST

Lowering the yellow, raising red slightly, and raising blue and cyan all reduce the contrast.

DINKA BOY

The original is a good starting point for a mono conversion targeting mid-tones.

When converting, as here, it helps the effect not to close up both black and white points, and then to lower the contrast. Visually this forces more attention to the mid-tones. The methods used here are first to use hue adjustment to bring tones closer together (for example, see what lowering the yellow does to the out-of-focus background at upper right), and then to apply a traditional contrast-reducing curve overall.

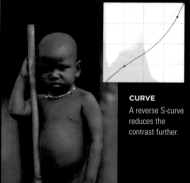

CURVE

A reverse S-curve reduces the contrast further.

the paper's surface, as opposed to a silver print in which the image-forming silver lies in a gelatin coating. While the deepest platinum blacks are not as black as those in a silver print (which has a higher D-Max, in technical terms), the tonal separation within the range is remarkable. Mid-tones appear particularly expanded, and a large amount of detail is visible in the shadows. While there is no satisfactory way of simulating this in a digital image, the ideal of good separation and a long tonal range can still be pursued.

Mid-tones

Mid-tones define themselves, but it's important to remember that this is a common-sense definition and does not lend itself to precise figures and levels.

Mid-tones simply mean the usually large middle of the brightness range, everything except the shadows and the highlights. For more precision we need to go to the Zone System, but the significance of the term "mid-tone" lies in the way we see and perceive. The human eye adapts wonderfully and rapidly to changes in brightness, but within any one range of tones, will tend to settle on the middle. Metering systems, and most photographers unconsciously, do the same with exposure. In a straightforward, single-

subject image, a clear subject of attention tends to look "right" when it is rendered in mid-tones. Most of us follow this so naturally that it seems too obvious to mention, but it is fundamental. And it is even more true of a monochrome image than one in color, as a striking hue in the highlights or shadows can catch the attention, deliberately or otherwise. A rich sunset, for example, draws more attention to the highlights in a color image.

There's no need to be obsessive when you are setting the limits, and as both the examples here show, many images resolve themselves easily into shadows, mid-tones, and highlights. In the case of the cheetah, the animal is so obviously the only subject

EXPLODED LAYERS VIEW
Exploded layers separate this image into shadow, mid-tone, and highlight.

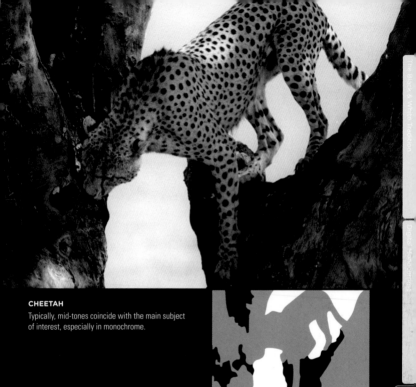

CHEETAH

Typically, mid-tones coincide with the main subject of interest, especially in monochrome.

that the shadows (the darker recesses of the tree) and highlights (the background) exist only for the composition—details within them would be irrelevant. As we've seen elsewhere, black and white allows more extreme processing than color, without looking "wrong." In a case like this, clipping in shadows and highlights would be perfectly acceptable.

149

Contrast High

Black and white lends itself to high-contrast treatment much more so than color for two reasons.

One is that monochrome is not held in check by the expectation that it is a faithful and realistic version of things, as we saw on pages 58–61. The other is that increasing contrast is a particularly good way of emphasizing structure and form—and these are key qualities in black-and-white photography.

The traditional S-curve that raises the lower highlights and lowers the mid-shadows is the standard tool for raising contrast globally across the image. By choosing how high or low to put the points that you drag, and by adding more than two points, it can be fine-tuned for subtly different results. Nevertheless, in the face of newer processing tools and more time-consuming methods, it is a little crude. This is fine for many, even the majority of images, possibly, but by no means always the ideal.

Here, we look at a more considered way of selectively increasing contrast, using a variety of tools on two images. The first, on these two pages, is at a Dinka cattle camp in southern Sudan. While the

color image is workmanlike, it seemed to have potential as a high-contrast image in black and white. In particular, there is the play between the black and white of the foreground cow, the correspondence between the curve of its shoulder and neck and that of the other animal's horns, and the skin of the young cowherd.

However, adjusting the hues offer two opposing contrasts. In one, the first here, lowering yellow and maximizing green, cyan, and blue gives the highest contrast with the out-of-focus background. The second choice, maximizing yellow and red, gives the greatest contrast in the lower half of the frame. One possibility, therefore, was to do both separately, and then blend the two versions manually, as shown here. Broad strokes, erasing one layer over another, are sufficient. Following this, a fairly strong use of Photoshop's Shadows/Highlights control increases local contrast.

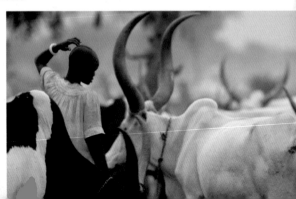

ORIGINAL
Color original.

Black and White

Reds:	-31%
Yellows:	-62%
Greens:	300%
Cyans:	300%
Blues:	300%
Magentas:	51%

STEP 1

Raising cool colors and lowering warm ones.

Black and White

Reds:	100
Yellows:	198
Greens:	40
Cyans:	60
Blues:	20
Magentas:	80

STEP 2

Raising yellow and red tones.

STEP 3

Shadows/Highlights settings to emphasize mid-range contrast.

Shadows/Highlights

Shadows

Vibrance	8%
Saturation	76%
Radius	54px

Highlights

Amount	35%
Tonal Width	7%
Radius	30px

Adjustments

Color Correction	+20
Mid-tone Contrast	+52
Black Clip	0.01%
White Clip	0.01%

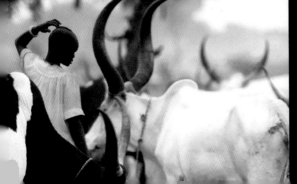

BLENDED

The finished manual blend.

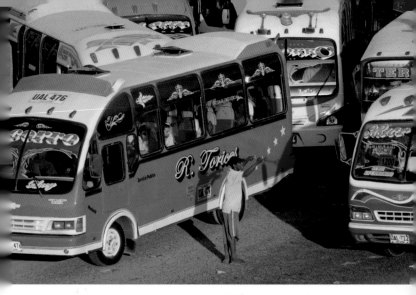

This image has been chosen to make a direct comparison between two ways of heightening contrast. The overall results are similar, but the specifics are very different. The scene is a bus terminal in Cartagena, Colombia—the sunlight strong and low, the color red! The aim, in converting to monochrome, is to convey this intensity in the absence of the rich red. Step one is to make the usual default conversion as a benchmark, and work from that.

The standard method would be to apply an S-curve, as shown here, and the result is good. But now let's try and achieve the same overall degree of contrast in a different way—by adjusting only the hues. The obvious approach is to go for a bright red, so although there are few cool tones in this late afternoon scene, we can take cyan and blue down to their minima. Next, we raise the red slider until just before the side of the bus goes to featureless white—we still want some hint of detail. The result is high contrast to the same degree as with the S-curve, but with a different distribution of tones—strange if you knew the starting point was red.

We can also go for the opposite conversion, a dark red. Lowering the red slider does this, but also, because the entire scene is diffused with warm sunlight, it darkens everything. The solution is simple—raise the yellow slider to lighten overall while still leaving the red dark.

CONVERSION ALTERNATIVES

HIGH CONTRAST CURVE

A conventional S-curve and the high-contrast result.

Black and White

Reds:	155%
Yellows:	60%
Greens:	40%
Cyans:	-200%
Blues:	-200%
Magentas:	80%

HIGH RED

Red is raised as high as possible without clipping.

Black and White

Reds:	-100%
Yellows:	60%
Greens:	40%
Cyans:	60%
Blues:	20%
Magentas:	80%

LOW RED 1

Lowering red for maximum dark rendering.

Black and White

Reds:	-100%
Yellows:	220%
Greens:	40%
Cyans:	60%
Blues:	20%
Magentas:	80%

LOW RED 2

The red is the same as "Low red 1" above, but the yellow is raised for an overall lighter look.

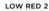

Contrast Low

Continuing the interpretation theme in which black-and-white imagery can be given a wide range of treatments, certain classes of scenes respond well to a low-contrast approach.

Of course, any scene can be lowered in contrast, and it ultimately depends on the vision of the photographer, but some picture situations are obvious candidates. Fog, mist, rain, indeed any softening effect from the atmosphere, has a certain degree of evocative appeal, and maintaining it means keeping off the black and white points. The histogram accompanying the as-shot image of trees in Dedham Vale, England shows just how much space can typically be found on either side of the tonal range. Low-contrast images like this tend to sit well inside the scale, with no blacks and no whites. This gives a great deal of latitude for exposure and key, meaning that increasing exposure by about a stop would simply shift the histogram to the right without any clipping, and decreasing by the same amount would do the reverse.

One way of reducing the contrast further would be to lower the red slider, given the reddishness that suffuses the original color images, from the just-risen sun. Or, there is always the temptation to close up the black and white points, as shown here. This really is a matter of taste, and many people would prefer this, though not me. This deserves a warning—digital practice has introduced photographers to technical tools such as the histogram, adjustable curves, black and white points, which is all to the good, but it has also created some automatic responses, that are not ideal. Most careful photographers check the black and white points in an image, but the unthinking reaction of closing them up exactly to just below clipping does no favors to a photograph that deserves to be delicate and nuanced.

LOW-CONTRAST SCENE

Limestone peaks and pillars glimpsed through shifting clouds around the summit of Huangshizai in Hunan are typical of the landscapes that inspired generations of Chinese artists working with brush and ink.

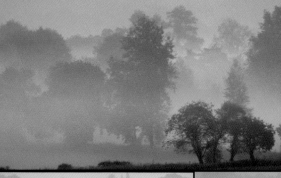

LOW-CONTRAST CONVERSION

DEDHAM VALE
The color original, bathed in the warm tones of sunrise.

Black and White

Reds:	-49%
Yellows:	60%
Greens:	40%
Cyans:	60%
Blues:	20%
Magentas:	80%

DEFAULT
The default conversion.

LOW RES
Reduced red component further reduces contrast.

CONTRAST-ENHANCED
This is the default conversion (which the histogram matches) with the points closed in, as indicated beneath the histogram.

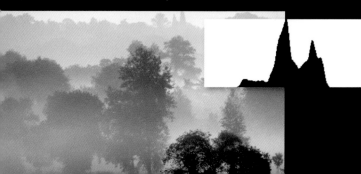

Shadow & Darkness:
Brandt & McCullin

A very different aesthetic of printing from the essentially "straight" and "pure" style promoted by Edward Weston and the other Californians is the sombre low key of heavily inked images, with mid-tones pushed down so that most of the detail has to be read in low values.

The reasons for wanting to do this vary from a love of the richness of heavy blacks to trying to match the mood of serious, even threatening subject matter, or even reflecting the mood of the photographer. Two photographers in particular stand out: Bill Brandt, who photographed Britain from the 1930s through the 1960s, creating a number of iconic images; and Don McCullin, best known for his war photographs from Cyprus to Beirut, but who then turned his attention to landscape.

In both cases, there seems to have been a progression over time toward printing darker. In the case of Brandt, his wife said of his pictures of buildings in Newcastle that they "looked to him as if they might have been built of coal." It also tended to fit quite well with his obvious liking for strongly geometrical compositions—these normally lend themselves to high-contrast treatment.

Don McCullin recognizes in his dark, heavy printing a reflection of his childhood and career, writing, "[M]y eyes had grown accustomed to the dark. All I saw seemed to echo my childhood and the scenes of deprivation, dereliction, death and disaster, smashed minds, and broken bodies, that I had witnessed in other countries." This preference has been transferred to his current landscape photography of his home in Somerset, in the south-west of England. In an interview with broadcaster John Tulsa, he said, "I look forward to the evening light and the naked trees when I go out; and I live in this Arthurian world of Somerset." In many ways, McCullin's later work exemplifies the idea of the expressive print, full of personal feeling.

SHELTER PHOTOGRAPH TAKEN IN LONDON, NOVEMBER 1940
Bill Brandt

Low Key

While a darker key can be applied to any image, according to the mood of the photographer, certain kinds of lighting and scene lend themselves more readily to this treatment than others.

Ideal conditions occur when: a large area of the frame, even most of it, is in shadow; most of these shadow areas carry no essential detail; and when there is a structure of lighter tones to make a contrast. Indeed, contrast, if only on a finely detailed scale, contributes greatly to the success of many low-key images. But, as with all special treatments, from infrared to high key, simply following a formula of "this is a low-key kind of image" misses the point. What matters is how you, as an individual photographer, see the scene and the potential in it.

This example is reasonably conventional for low key—the setting is a dark interior, with weak side-lighting that reveals enough of the subject to make it obvious, and a background that can easily go to black. And probably should go to black in order to keep attention on the texture of the skin and beard. The histogram that you can see when we make the Levels adjustment is typical of a mainly dark image with low-key potential. The first step with this image, in order to strengthen the low-key effect, is to make the background as black as possible, but without losing important shadow detail on the man and his hat. In Photoshop Levels, holding down the ⌥/Alt key as you click on and drag the black point slider shows the amount of clipping, and updates it as you adjust the slider.

DARK SKIN

The color original, with brown in the skin and some cyan and blue in the white beard.

Normally with an image we would pull back from this to avoid clipping, but in this case some solid black is exactly what is wanted. In order to keep the mid-tones more or less as they were, it helps in this case to raise the mid-point slider by approximately the same amount as the black point has been closed in—from 1.00 to 1.20.

This is as far as we need to go, but there is still plenty of room for adjusting the white point or the mid-point to taste. And, of course, there is always the option of using the hue sliders to alter tonal relationships and contrast. Here there are two alternative versions: one to maximize the contrast between beard and skin; the other to minimize it. By now, the procedure should be predictable and straightforward. For the former, lowering red and yellow darkens the skin, raising cyan and blue whitens the beard. For the opposite effect, doing the reverse makes it possible to blend the beard in with the skin until it is almost unnoticeable—if that is the desired effect.

DEFAULT

The default conversion.

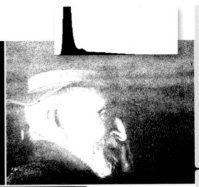

SHADOW CLIP

Above: Closing in the black point, which invovles holding down the ⌥/Alt key to view clipping as you adjust the levels sliders.

EMPHASIZE BEARD

Left: Settings to lighten the beard and darken the skin.

KNOCK BACK BEARD

Settings to blend the beard tones into those of the skin.

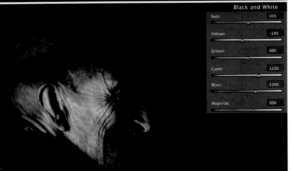

High Key & Graphic: Callahan & Hosoe

If style can be pushed toward darkness and shadows, as we have seen on the previous pages, it can also go in the other direction.

In the dark room, high key meant rationing the light from the enlarger and, in order to accentuate the few parts of the image allowed to remain in what is essentially a field of white, applying extensive local control—that is, dodging and burning. The digital equivalent of this takes pace in image-editing programs such as Photoshop, but a custom profile for the printer can also be made to accentuate the contrast and whiteness.

Harry Callahan, 1912–99, is known for his frequent use of high-key printing. Callahan's work changed direction after he met Ansel Adams in 1941, following which he adapted some of Adams' ideas. From this point on he added to his repertoire high-key abstractions, such as "Weeds in Snow," and certain portraits of his wife Eleanor (there were many, in different styles) in which her skin is rendered white and, in one instance, appears in silhouette emerging from almost-white water. For high key to work visually, it demands high contrast with the few remaining dark tones, and this inevitably leads to a graphic style. By this I mean imagery in which lines and points—the rawest graphic forms—dominate, while tonal gradation is suppressed. This in turn creates often-puzzling abstractions. Clearly, this aesthetic appeals to a certain kind of personality in which content is subordinated to form.

One important area of decision is whether or not to allow the edges of the extremely pale image to bleed into the surrounding paper. At one extreme, this effectively makes the image borderless, which can make for an interesting discussion in itself. The more traditional approach has been to hold the brightest tone a noticeable level darker than pure paper white, in order to hold the limits of the image, but the balance is a fine one because too far below white runs the risk of looking muddy. This issue extends to mounting and framing, as the eye of the viewer is inevitably affected by the difference in tone. One of Callahan's solutions to this was to frame the image in black—either the black of the film rebate or a printed-in black edge.

Japanese photographer Eikoh Hosoe, born in 1933, has made particularly strong use of dodging and burning-in to create his expressive prints that are frequently very high in contrast. His frequent use of areas of pure white, notably in his series of close-ups of the bodies of men and women juxtaposed and in images taken for the book *Kamaitachi*, have a direct connection with the tradition of the Japanese woodcut. In traditional Ukiyo-e prints, a proportion of which is erotic, men are often depicted with dark skin and women with white for deliberate contrast.

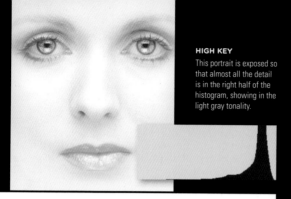

HIGH KEY

This portrait is exposed so that almost all the detail is in the right half of the histogram, showing in the light gray tonality.

VERY HIGH KEY

This shot uses a curve to exaggerate the already high-key shot to the point that its tone is reminicient of Harry Callahan's famous "Eleanor" shot.

161

High Key

As we saw from the previous pages, a high-key treatment depends on a large area and high value of whiteness, and on high contrast.

More fundamentally, for high key to work well, there usually needs to be some smaller, darker elements that are integral to the image. Raising the brightness and contrast throws emphasis on whatever smaller darker areas remain. Both of the examples here, in different ways, rely on this feature—small key subjects in an expansive white setting.

This first image, dawn over the Altausseer lake in Austria's Salzkammergut region, works well in color. Nevertheless, it lends itself to an effective high-key treatment. Critical to the image is that the fisherman in his small boat is seen against only the reflections of the mountains in the still water, not against the mountains themselves. The boat's position and size add to the delayed reaction in seeing it, consequently resulting in the "inversion" of the landscape. Making a high-key version, we should keep this in mind.

At this time of day, the mountains and sky in the reflection are bathed in blue, and so can be lightened and darkened, while the low mist is more white. Simply, raising the blue strongly, with cyan and red to a lesser degree (both are present in the bluish cast), whitens the image overall without affecting the rowing boat. In one stroke, we already have a high-key effect. The histogram is typical and the reverse of the low-key one on page 158. But we can take this further by closing in the black and white points to enhance the contrast. Simply doing this operation, however, also lowers the mid-tones, and to keep them high, the mid-point slider can be raised here quite strongly from 1.00 to 1.70.

Finally, there is always the option to go to a high-key extreme by clipping some of the whites. This would normally never do in color, nor in normal black-and-white processing. The result is a matter of opinion, but valid in that it draws even more attention to the man in his boat.

ALTAUSSEER SEE
The color original, suffused in the blue light of dawn.

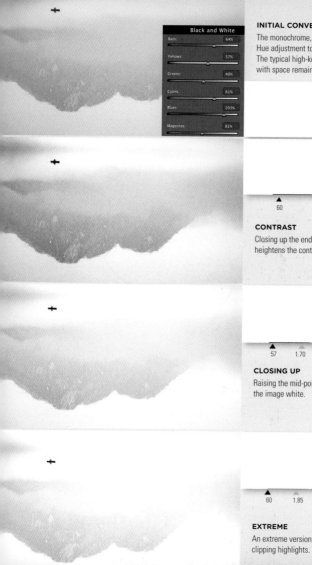

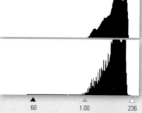

Black and White

Reds:	64%
Yellows:	57%
Greens:	40%
Cyans:	81%
Blues:	203%
Magentas:	81%

INITIAL CONVERSION

The monochrome, high-key version.
Hue adjustment to whiten the blues.
The typical high-key histogram, but
with space remaining on the right.

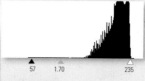

60 1.00 236

CONTRAST

Closing up the end-points
heightens the contrast.

57 1.70 235

CLOSING UP

Raising the mid-point keeps
the image white.

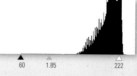

60 1.85 222

EXTREME

An extreme version, deliberately
clipping highlights.

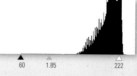

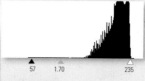

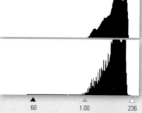

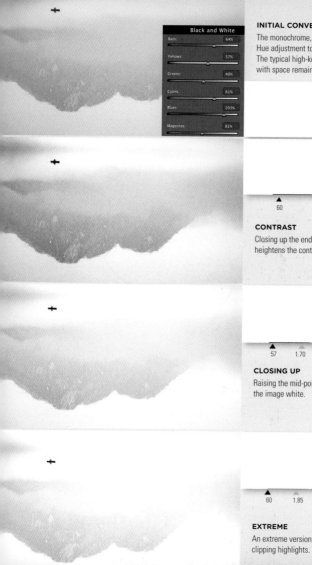

COLOR ORIGINAL
The color original, quite
low in contrast on an
overcast day.

This second example, twigs in snow, could have been tailor-made for a high-key conversion.

Here, hue adjustment will be integral, but to demonstrate the point, let's begin with the more standard method using Levels. The dead twigs and flowers are yellow, and so quite pale—not really much of a shot in color. Nevertheless, closing in the black and white points at least gets us to a very white image.

However, beginning with hue adjustment, the straw-colored twigs contrast with the bluish hint to the snow, so that pulling the hue sliders in opposite directions quickly gets us to a high-key result with strong contrast. The Photoshop preset High Contrast Blue is similar.

40 3.01 244

DEFAULT

The default conversion, with histogram, shows that there is still room for adjustment at both ends of the scale, hence not strongly high key.

Closing in the white point and strongly raising the mid-point gives a high-key result with just moderate contrast.

HIGH CONTRAST

Starting again from the color original, lowering the warm tones and raising the cool tones arrives directly at a high-key, high-contrast result.

HIGH-CONTRAST BLUE

Photoshop's High Contrast Blue settings do much the same thing as my "High contrast" ones in this case.

Black and White

Reds:	21%
Yellows:	-85%
Greens:	40%
Cyans:	118%
Blues:	131%
Magentas:	80%

Black and White
Preset: High Contrast Blue Filter

Reds:	21%
Yellows:	-85%
Greens:	40%
Cyans:	118%
Blues:	131%
Magentas:	80%

Digital Zone System

Ansel Adams et al's Zone System never seems to go away, despite the fact that it was invented for a specific kind of photography that very few people ever practiced—namely black-and-white sheet film over which the photographer could ponder without being in a rush.

Such is the power of belief in old masters. The fundamental question for using it in digital photography is not how but why. I'll admit that I'm treating it here out of a sense of duty, and also because if you are a committed black-and-white photographer, you will expect to see it here. Nevertheless, it has little value in its original intended way, which was not simply to place a key tone in a particular zone and then see how the other tones would fall, but rather to then adjust the exposure and processing if needed. This was perfectly possible with a single sheet of black-and-white film, usually impractical with a roll of film, and pointless with digital capture.

That said, it is a useful way of assessing scenes and images. This is all to the good, as I suspect that many photographers believe anyway that it is just a tool for analysis, and either skip or have never heard of its practical use in developing a negative. It's worth reviewing this in order to put the Zone System in proper perspective for digital shooting. The basic procedure involved first measuring the range of brightness in the scene, then choosing a key tone, then seeing how everything else would reproduce relative to that key tone, and then making the exposure in anticipation of pushing or pulling the development. I use the term pushing to mean forcing development, to give something similar to the result of using a higher ISO film. Pulling means the opposite, reducing development. The techniques are unimportant here, but they generally involved raising or lowering the temperature of the developer, and increasing or reducing the development time. More important was that altering the development also alters the contrast. Crudely put, pushing increases contrast, pulling flattens it.

In practice, this meant that, in the terminology of the Zone System, you chose your important tone and placed it in a particular zone. All the the other tones then fell into various zones. If that created a problem, such as shadow areas that were too dark (in too low a zone), you would adjust the development to expand or compress the contrast. This adjustment of contrast through development is meaningless for digital photography. It was also meaningless for most 35mm or roll-film shooting, as the altered development would affect every other frame, and was designed for sheet film.

Now, as all of this is unnecessary in digital photography where the processing tools are much more sophisticated and flexible, it remains to treat the Zone System as an evaluation system. In this, it continues to shine. The table opposite is crucial because it assigns meaning to tones. And while every tone has some importance, certain zones are typically critical, particularly Zones III (textured shadow), V (mid-tones), and VII (textured brights).

...ternative version of the Zone System has 11 zones instead of the ten shown here, and yet another has
Note that we show two versions of the scale here, one of solid tones, the other with an added texture.
...school of thought holds that textured zones are closer to the reality of a scene, and so easier to judge.

ZONE 0	Solid, maximum black. 0,0,0 in RGB. No detail. In digital photography, the black point goes here.
ZONE I	Almost black, as in deep shadows. No discernible texture. In digital photography, almost solid black.
ZONE II	First hint of texture in a shadow. Mysterious, only just visible. In digital photography, the point at which detail begins to be distinguished from noise.
ZONE III	Textured Shadow. A key zone in many scenes and images. Texture and detail are clearly seen, such as the folds and weave of a dark fabric.
ZONE IV	Typical shadow value, as in dark foliage, buildings, landscapes.
ZONE V	Mid-tone. The pivotal value. Average, mid-gray, an 18% gray card. Dark skin, light foliage.
ZONE VI	Average Caucasian skin, concrete in overcast light, shadows on snow in sunlit scenes.
ZONE VII	Textured Brights. Pale skin, light-toned and brightly lit concrete. Yellows, pinks, and other obviously light colors. In digital photography, the point at which detail can just be seen in highlights.
ZONE VIII	The last hint of texture, bright white. In digital photography, the brightest acceptable highlight.
ZONE IX	Solid white, 255,255,255 in RGB. Acceptable for specular highlights only. In digital photography, the white point goes here.

Digital Zone System

In this image, of the Temple of Luxor at sunrise, we can make an initial at-a-glance assessment. For me, this would be that the overall range of sunlit sandstone should be lighter than a mid-tone, simply on the grounds that the eye expects a certain degree of brightness from clear sunlight. Also, the sky needs to be a touch less than pure white—there would certainly be no excuse for clipping it to blank white. Also, all the shadow areas other than the very deepest small ones should "read," with discernible detail.

In many situations, this is all that there is time for, but assuming that the camera is framed and locked down, and nothing unexpected is about to happen, we can assess further in the true Zone System manner. To simplify matters, I've converted the scene into a version in which each solid block of tone is approximately one stop different to the next lighter or darker tone. Note that at this stage (supposed to be at the time of setting up the camera), the actual values are not set and can be shifted higher or lower. Later, digitally, they can also be changed relative to each other during processing, an action that was not anticipated by the inventors of the Zone System, and which invalidates the system as a practical processing tool (though not as an evaluation tool).

The classic procedure is to have already made and printed your own zone scale, from solid black to pure white. This is easy enough to do with a digital printer, although achieving a dense black is a challenge. Armed with this scale (the numbers printed on it shown in the examples are not strictly necessary, but included here to avoid any confusion), the dedicated Zone System photographer can then hold it at arm's length against the scene, and try to match key zones on the scale to those in the scene.

This procedure is represented here. My first concern has to do with the shadows, because while the mid-tones in general will need to be fine-tuned, they can more or less take care of themselves in any reasonable exposure. As the statue is the first focus of attention, the shadow areas below the knees and on the side of the face, assume a particular significance. I want them to read, but not obviously. From the zone scale assessment, they should be somewhere between Zone II–III.

Next, we can check the sunlit areas of sandstone. Moving the scale over them, we can see that they cover three f-stops of tone. Because they are lit by sharp sunlight, I think they should overall appear brighter than average in the final version, so a reasonable and safe way of deciding this is to find the darkest area of sunlit stone and place that at Zone V. With this decision taken, all the other zones fall into place satisfactorily. The Zone System proves useful in analyzing the scene and reaching this decision, but were there to be any relative adjustments, such as raising a shadow area without raising everything else, I would do it with any of the several digital procedures that we've looked at already; the Zone System would have no part to play in this. This image was chosen, naturally, for its not needing any special processing.

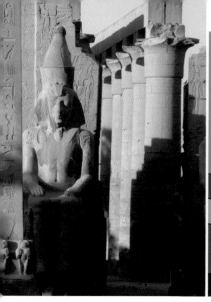

ZONING

The Temple of Luxor at sunrise, a full-range scene with the focus of attention falling on the sunlit areas of stone, notably the seated figure.

FINDING 1

Finding Zones II to III.

BLOCKS

For convenience, the scene translated into blocked-in segments.

FINDING 2

Looking for Zone V—mid-tones.

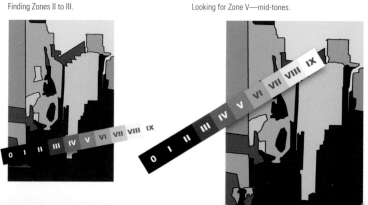

65%

%

65%

20%

75%

55%

75%

65%

20%

25%

0%

20%

15%

10%

0%

VIII

VI

IV

V

VII

IV

II-III

II-III

I

BRIGHTNESS SEGMENTS

At the chosen exposure, these are the brightness measurements for the average of each segment.

ZONES

Above right: The brightness of each segment translated into numbered zones.

ORIGINAL IMAGE
For reference.

KEY BRIGHTS

Because of digital sensors' linear response to light, the highlights are critical in many, maybe most, images. Certainly, accurately assessing the top values in an image is a key skill, and Zone System thinking can help here. In this example of whitewashed pagodas in Mandalay, Burma, the sunlit white is the key tone in the photograph, and from the Zone System needs to be Zone VIII—"last hint of texture." The next most important tone is the light shadow that appears on the far left of the left-hand pagoda, just below the center. This tone also appears in the middle of the center and right rows of

pagodas, and is about one zone (one stop) darker than the highest white, which is as we would expect it to be: Zone VII—"textured brights." In the default Raw processing using Photoshop, the highest white is about half a stop darker than it needs to be. However, raising the exposure by one stop shows how fragile these whites are—there is a serious loss of highlight detail, with clipping. However, if instead we raise the contrast in the Raw processor while leaving the exposure and brightness alone, we achieve in one stroke just the right white highlight and an expanded separation.

DEFAULT
The default conversion of the color original.

EXPOSURE RAISED
Exposure raised by one stop from the default.

MAXIMUM CONTRAST
Maximum contrast applied to the default black-and-white conversion.

HDR in Black & White

High Dynamic Range photography (HDR) has rapidly achieved a popularity way beyond early expectations.

The original techniques were invented as a means of capturing the full range of tones in scenes containing both deep shadows and the light source itself (for example, the sun). The results can be anything from naturalistic to surreal, and it is this range of possibility that attracts so many photographers.

First, the basics. High Dynamic Range simply means a higher range of brightness than a normal camera can handle, and involves scenes that can be captured in their entirety only by taking a sequence of frames at different exposure settings, and then combining them. A high-end digital SLR has a dynamic range of around 14 stops, while an into-the-sun shot is more likely to have a range in excess of 20 stops.

In practical HDR photography there are three steps. First is capture, using a sequence of shots. Second is combining this sequence of images into a single HDR image file that contains all the brightness levels, more than can possibly be seen on a standard monitor or in a print. Step three is a software process of compressing all this information into a viewable form—in other words, an 8- or 16-bit image. This last step is the most demanding and most varied, and involves a software processing procedure called "tone mapping." More on this in a moment, but interestingly, tone mapping can also be applied to regular, non-HDR image files, with equally interesting results.

Capture

Capturing a full range of brightness means keeping the camera completely still, ideally locked down on a sturdy tripod. Nevertheless, HDR creation software is nowadays good enough to be able to deal with slight movements between frames, (and copes with small areas of moving objects through a process known as "deghosting").

The ideal spacing of exposure settings between frames is two stops, but don't worry if you're camera's automatic bracketing goes no higher than one stop—the important thing is shoot the number of frames necessary to capture the full brightness range. Aim for the following: the darkest exposure shows no highlight clipping—but only just—while the lightest exposure should have the darkest shadows as mid-tones. Provided that you use the camera's on-screen highlight clipping warning and the histogram, calculating the settings is easy. Remember, though, that the only adjustment to the exposure settings required is to the shutter speed, not the aperture, because this will change depth of field and so interfere with registering the images later.

If you're working manually, begin with the darkest exposure. A couple of trial-and-error shots should get you to the exposure. Find the setting at which there is just a tiny amount of highlight clipping warning, then reduce by 1/3 or 1/2 stop from there. This sets one end point of the sequence. For the second shot, open up by

two stops on the shutter speed, for example, from 1/500 to 1/125 second. Do the same with each subsequent frame, until the on-screen image looks almost completely overexposed. For these later shots, keep the histogram displayed on the camera's screen, and continue the sequence until the left-hand edge of the histogram is in the middle of the scale. If in doubt, over shoot, as you can always delete frames later. One of the most common mistakes is not continuing the sequence far enough. You want the last frame to have no blacks whatsoever, and the darkest tones to appear as mid-tones.

That is all there is to it. As mentioned, most HDR software today has content-recognition algorithms that can usually

HDR THEATER
A fully processed shot of this theater creates a picture with detail to explore everywhere.

cope with slight movements, and this is not just a safety net for minor knocks of the tripod; it also makes it possible to shoot handheld—if you are careful and take some precautions to minimize movement. Without a tripod, use whatever surface and support you can find to help you brace. Use the camera's auto-bracketing, and set the shooting mode to the highest frame rate possible.

Generating the HDR File

There are now several software applications that will accomplish HDR file merging, and each one has its particular method, but for simplicity we will stick to three popular ones: Photomatix Pro, HDR Efex Pro, and Photoshop's Merge to HDR Pro. From the user's point of view, merging the source images is the simplest step in the operation and needs little or no intervention. Choosing the option to align images takes longer, but is safer. If there was movement in the scene, and if the option is available, choose to remove it. Once the merging to HDR is complete, you will have a single file with 32 bits per channel instead of the usual 8 or 16 bits. It is, of course, impossible to view this range of detail on a normal 8-bit monitor, and it will look unpleasantly contrasty, but this is irrelevant. A good step here is to save the image in one of the available HDR formats. For most purposes, it does not matter what you choose, but the most common is Radiance (.hdr), and the most economical in file size is Open EXR (.exr). It is not essential to save the HDR image, and you can instead proceed directly to the third step, tone mapping. However, if you are likely to want to revisit the HDR for an alternative tone mapping, you would then need to go through the HDR generation again. In this case, saving the HDR can save time.

The most accurate HDR generation is, as you might expect, directly from Raw images, and this is always recommended. However, if you are aiming for a black-and-white HDR result, you are likely to find

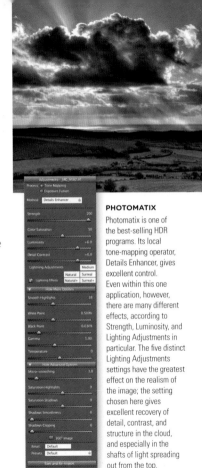

PHOTOMATIX

Photomatix is one of the best-selling HDR programs. Its local tone-mapping operator, Details Enhancer, gives excellent control. Even within this one application, however, there are many different effects, according to Strength, Luminosity, and Lighting Adjustments in particular. The five distinct Lighting Adjustments settings have the greatest effect on the realism of the image; the setting chosen here gives excellent recovery of detail, contrast, and structure in the cloud, and especially in the shafts of light spreading out from the top.

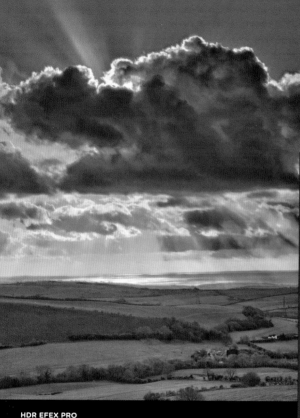

Preset Categories

All | Classic
Modern | Vintage
Favorites

08 Structures Skies

09 Vibrant Textures

10 Vibrant Details &...

11 Monochrome, Co...

12 Monochrome, Soft

13 The Old Cottage

HDR EFEX PRO

HDR Efex Pro is another popular HDR program, more recent than Photomatix.
Developed by the successful software company Nik, Efex Pro, like Photomatix HDR
Pro offers a good level of control, and, also like Photomatix, numerous presets.
Unique to Efex Pro is Nik's U-Point adjustment technology, which allows users to
place Control Points anywhere on the preview image and make localized adjustments

that you have more creative control if you convert the Raw images to monochrome before tone mapping. The alternative, going all the way through the process in color and then finally converting to black and white, is perfectly viable, but the creative choices during tone mapping are quite different between color and black and white. The easiest way is to convert the Raw sequence to monochrome in a Raw editor before exporting to the tone-mapping software.

Deghosting

Once merging is complete and before proceeding to tone mapping, you may need to run a deghosting algorithm to address any issues of objects moving between frames. Depending on the software you're using this may be fully or semi-automated, but should always be straightforward. Results vary between applications, but are improving all the time.

Tone Mapping

This is where all the work, and the fun, takes place. The algorithms, however, are complex and vary greatly from software to software. It helps to have some degree of understanding of what goes on in tone mapping in principle. This is the stage in the procedure in which the software attempts to squeeze the huge dynamic range in the HDR image into a much smaller bit depth so that it can actually be viewed in a normal way, on a screen or in a print. Simply compressing all the tones toward the middle equally will not produce

a pleasing or realistic result. All of the useful tone-mapping operators, as the software is called, employ a method to take into account the local neighborhoods in an image. For example, the extremely bright edges of a backlit cloud are likely to need a different scale of compression than the details of tone mapping, but knowing more does not necessarily help in what is for most photographers a mainly creative process in experimenting with effect. Each tone-mapping program has its own quirks and procedures, so familiarity with results is actually more useful than an in-depth understanding of the mathematics involved, which can be very involved at any rate.

It's possible to spend a great deal of time and energy getting to grips with the details of tone mapping, but knowing more does not necessarily help in what is for most photographers a mainly creative process in experimenting with effect. Each tone-mapping program has its own quirks and procedures, so familiarity with results is actually more useful than an in-depth understanding of the mathematics involved, which can be very involved at any rate.

One of the characteristics of HDR tone mapping is a kind of halo around the border between strong contrasting tones, such as a roofline against a bright sky. The width of the halo can usually be adjusted with the tone-mapping controls, and making the width high is one way of reducing its appearance. Essentially, haloing is a failure of the software to recognize and deal with sharp tonal boundary edges; from a purist point of view, this is a fault. However, from the point of view of creative interpretation, haloing can produce effects that many people like. The issue is contentious, but

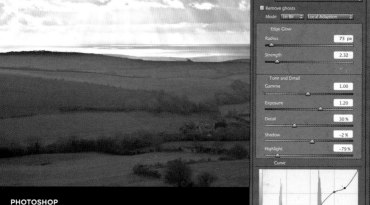

Preset: Default

Remove ghosts

Mode: 16 Bit · Local Adaption

Edge Glow

Radius · 73 px

Strength · 2.32

Tone and Detail

Gamma · 1.00

Exposure · 1.20

Detail · 30 %

Shadow · -2 %

Highlight · -79 %

Curve

Input 85 % · Output 81 % · Corner

PHOTOSHOP

Previous versions of Photoshop's tone-mapping command, Merge to HDR, won few admirers. It lacked control and results were variable depending on the source sequence. The more recent Merge to HDR Pro version is much improved and offers much more in the way of control and processing options. Compared with dedicated software, such as Photomatix and HDR Efex Pro, however, it still feels less intuitive and getting the result you want often seems to be a case of trial and error.

 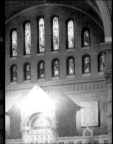

1/2 second, *f*/22 2 seconds, *f*/22 8 seconds, *f*/22 30 seconds, *f*/22

one of the interesting qualities of black and white is that it can absorb haloing better than color. A broad halo is, after all, simply a tonal gradient, and with color removed from the equation this is by no means always objectionable—even to people for whom a halo is an artifact.

Interpretation

Tone mapping can be as much about skill, taste, and style as technicalities. With so many adjustable tools, and many quite different algorithms invented by software developers, there is no such thing as a standard procedure. In particular, each image has its own characteristics, and even experienced HDR users are unlikely to be able to predict exactly which settings will produce a desired result. Tone mapping calls for experimentation. In this example of a church interior (one of the classic HDR picture situations), two versions

out of many show the contrast between an approach geared to revealing detail and an approach aimed at reproducing atmosphere (which includes the glow—actually flare—from the spotlighting).

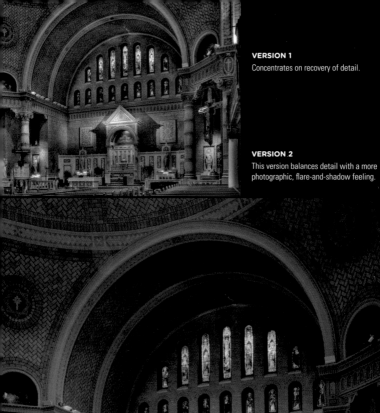

VERSION 1

Concentrates on recovery of detail.

VERSION 2

This version balances detail with a more photographic, flare-and-shadow feeling.

Tone Mapping without HDR

The tone-mapping procedures that are so necessary when shooting HDR can also be applied to ordinary, non-HDR images, and we can treat it as its own form of post-prouction.

In fact, tone mapping has crept into most processing software suites, although it is not always identified as such. The value is that it offers a different kind of control for recovering detail and for adjusting contrast in local areas of brightness or shadow. Just how these effects compare with the classic curve-based methods deserves experimentation, not least because aggressive use of tone-mapping produces artificial-looking images that may seem to lack traditional "photographic" qualities.

Probably the most-used tone-mapping method is Adobe Photoshop's Shadows/Highlights adjustment. This method is radius-based and allows lightening and contrast control of shadows, darkening and contrast control of highlights, together with contrast adjustment of the mid-tones in between these two zones. While I have no intention of giving a tutorial on this method here (there are other sources for that), it is worth promoting an exploration of what it can do as part of the post-production workflow.

But there are also ways of using HDR tone mapping. The starting point is to export a single Raw file from your Raw converter to an HDR application.

Shadows
1. Amount: Strength of lightening, modest here 2. Tonal Width: 30% tonal width extends lightening to this shade of gray 3. Radius: High radius because shadow areas are extensive

Highlights
4. Amount: Strength of darkening, just a little, otherwise highlights would be flat 5. Tonal Width: Width covers just the torso tones 6. Radius: Lower radius for highlights because their extent is less than that of the shadows

Adustments
7. Color Correction: No color correction needed for monochrome 8. Mid-tone Contrast: A slight amount of increased contrast to the middle grays

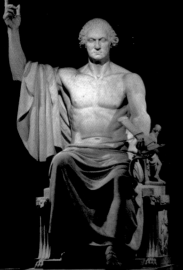

THE FINAL IMAGE

With shadows opened, torso highlights moderated, and a slight increase of contrast in the mid-tones in between. The base shadow background has been kept rich.

Alternatively convert a 16-bit TIFF to 32-bit and then save it in one of the HDR formats, such as Radiance. In fact, if you stay within Photoshop, simply the conversion to 32-bit gives you access to the Photoshop tone-mapping algorithms when you return to 16-bit mode. The example here uses a processed TIFF converted in Photoshop to OpenEXR and then tone mapped in Photomatix.

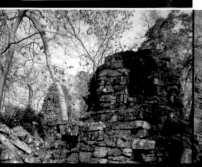

STANDARD CONVERSION

"Normal" processing was used in this photograph taken in a ruined Khmer temple in Banteay Chhmar.

DETAILS ENHANCER

Using Photomatix's local tonemapping operator, Details Enhancer, quite a different look is created, which is less

Adding Tints

From very early in the history of photography, it was realized that bathing the developed print in certain chemical solutions could do two things: improve the stability of the image and/or add a colored tint.

For the purpose of adding a tint, toning was generally used according to how the printer (very frequently the printer was also the photographer) felt the image would respond.

Sepia, selenium, gold, and platinum toners were the most widely used. Each worked by replacing the metallic silver present in the print (which gave black) with another compound or metal. Sepia toning uses a sulfide compound; selenium converts silver to silver selenide, with a red-brown to purple-brown effect depending on the strength; platinum and gold are metal replacements, with gold giving a blue-black tint.

All of these are easily reproduced digitally, either by manipulating individual channel curves, or by taking advantage of the presets that several processing applications offer. A further development is "split-toning," which chemically could be the result of a wide range of processes, including imperfect fixing. Typically, contrasting tints, such as yellowish against bluish, are present in the same image, most usually split according to density. Thus, the shadow areas can be one tint, the highlights another. Again, this can be done digitally by using curves or making alternate highlight and shadow selections, or by using split-toning sliders in some processing software.

TWO VERSIONS OF SPLIT-TONING

Contrasting hues are applied to darker and lighter areas using the plugin Silver Efex Pro.

...oom's Split Toning pane allows you to choose a separate color ...e highlight and shadow regions, and set the saturation for each. ...dition, you can also adjust the point at which highlights and ...ows meet using the Balance slider.

PHOTOSHOP DUOTONE

Photoshop's Duotone command features a staggering number of presets to choose from, some of which are, strictly speaking, tritones, as shown here. And if none of the presets is right for your image, you can choose your own colors and even determine how they display in the image by using a Curves adjustment.

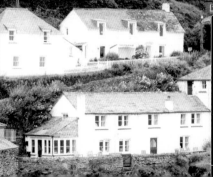

Old Process Effects

One of the services that digital photography and broadband sharing has performed has been to stimulate interest in all aspects of photography.

Now more than ever there are revivals of old photographic processes—or at least in their visual effect if not in the actual processing. While the goal of most digital photographic technology is perfection of image quality, processes like the cyanotype and the calotype offer atmospheric qualities that for some photographers have more resonance.

The whole question of simulation is a disputed one. The objections tend to fall into two camps: one, that simply approximating an effect by digital manipulation is false, and two, that it veers toward pictorialism, which for a large part of the American history of photography was despised. These are both, however, matters of judgment, and I don't intend to pass mine here. The argument *for* simulating old processes is that these historical techniques threw up styles of imagery that were interesting in themselves, and that digitally we now have the opportunity to learn what caused them, and to recreate them—the visual result rather than the process.

Processing software and plugins have preset effects, and applications such as Lightroom, Silver Efex Pro, and even HDR Efex Pro, among others, have between them a good selection of these old effects. These are displayed here.

SILVER EFEX PRO'S ANTIQUE PLATE II
Featuring fading, vignetting, and discoloration.

LIGHTROOM'S AGED PHOTO

left: Despite the faded tones retains a good level of detail.

LIGHTROOM'S CYANOTYPE PRESET

above: Successfully produces the blue tones that were closely associated with this once popular process.

SEPIA PRESET

above: Another Lightroom preset, this time recreating the famous sepia toning that has an enduring quality.

HDR EFEX'S VINTAGE COLORS

right: Like its cousins Antique Plate II, this also exhibits fading edges and vignetting.

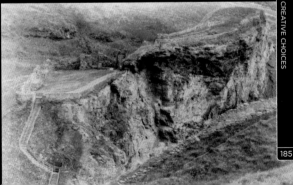

Glossary

ADJUSTMENT LAYER

A layer in a Photoshop image that adjusts the appearance of layers beneath it, and keeps editing adjustments separate from image data.

ALPHA CHANNEL

A grayscale version of the image that can be used with the color channels for saving a mask or selection.

APERTURE

The opening behind the camera lens through which light passes on its way to the image sensor (CCD/CMOS).

ARTIFACT

A flaw in a digital image.

BACKLIGHTING

The result of shooting with a light source, natural or artificial, behind the subject to create a silhouette or rim-lighting effect.

BIT (BINARY DIGIT)

The smallest data unit of binary computing, being a single 1 or 0.

BIT DEPTH

The number of bits of color data for each pixel in a digital image. A photographic-quality image needs eight bits for each of the red, green, and blue channels, making for a bit depth of 24.

BLENDING MODE

The calculation that controls how one Photoshop layer is composited with another.

BLOWN OUT

Containing no detail, usually referring to overexposed parts of an image.

BRACKETING

A method of ensuring a correctly exposed photograph by taking three shots; one with the supposed correct exposure, one slightly underexposed, and one slightly overexposed.

BRIGHTNESS

The level of light intensity. One of the three dimensions of color in the HSB color system. See also Hue and Saturation

BYTE

Eight bits. The basic unit of desktop computing. 1,024 bytes equals one kilobyte (KB), 1,024 kilobytes equals one megabyte.

CCD (CHARGE-COUPLED DEVICE)

A tiny photocell used to convert light into an electronic signal. Used in densely packed arrays, CCDs are the recording medium in most digital cameras.

CHANNEL

Part of an image as stored in the computer; similar to a layer. Commonly, a color image will have a channel allocated to each primary color (e.g. RGB) and sometimes one or more for a mask or other visual effects.

CLIPPING

An absence of detail in image areas because the brightness values record either complete black or pure white.

CMOS (COMPLEMENTARY METAL-OXIDE SEMICONDUCTOR)

An alternative sensor technology to the CCD, CMOS chips are used in ultra-high-resolution cameras from Canon and Kodak.

CMYK (CYAN, MAGENTA, YELLOW, KEY)

The four process colors used for printing, including black (key).

COLOR GAMUT

The range of color that can be produced by an output device, such as a printer, a monitor, or a film recorder.

COLOR TEMPERATURE

A way of describing the color differences in light, measured in Kelvins and using a scale that ranges from dull red (1900 K), through orange, to yellow, white, and blue (10,000 K).

CONTRAST

The range of tones across an image, from bright highlights to dark shadows.

CROPPING

The process of removing unwanted areas of an image, leaving behind the most significant elements.

CURVES

In Photoshop, a method of mapping pixels' brightness values to the value at which they are output.

DEPTH OF FIELD

The distance in front of and behind the point of focus in a photograph, in which the scene remains in acceptable sharp focus.

DIALOG BOX

An on-screen window, part of a program, for entering settings to complete a procedure.

DIFFUSION

The scattering of light by a material, resulting in a softening of the light and any shadows cast. Diffusion occurs in nature through mist and cloud cover, and can also be simulated using diffusion sheets and softboxes.

DMAX (MAXIMUM DENSITY)

The maximum density—that is, the darkest tone—that can be recorded by a device.

DMIN (MINIMUM DENSITY)

The minimum density—that is, the brightest tone—that can be recorded by a device.

DODGE

A photographic darkroom and digital image-editing technique to lighten part of an image.

DPI (DOTS PER INCH)

The standard measure of resolution.

F-STOP

The ratio of the focal length to the aperture diameter, expressed as $f/2.8$, $f/4$, $f/5.6$, etc.

FILTER

(1) A thin sheet of transparent material placed over a camera lens or light source to modify the quality or color of the light passing through. (2) A feature in an image-editing application that alters or transforms selected pixels for some kind of visual effect.

FOCAL LENGTH

The distance between the optical center of a lens and its point of focus when the lens is focused on infinity.

FOCAL RANGE

The range over which a camera or lens is able to focus on a subject (for example, 0.5m to infinity).

FOCUS

The optical state where the light rays converge on the film or CCD to produce the sharpest possible image.

FRINGE

In image editing, an unwanted border effect to a selection, where the pixels combine some of the colors inside the selection and some from the background.

GAMMA

A measure of the contrast of an image, expressed as the steepness of the characteristic curve of an image.

GRADATION

The smooth blending of one tone or color into another, or from transparent to colored in a tint. A graduated lens filter, for instance, might be dark on one side, fading to clear on the other.

GRAYSCALE

An image containing pixels with brightness value only on a black-and-white scale, and with no color data.

HAZE

The scattering of light by particles in the atmosphere, usually caused by fine dust, high humidity, or pollution. Haze makes a scene paler with distance, and softens the hard edges of sunlight.

HDRI (HIGH DYNAMIC RANGE IMAGING)

A method of combining digital images taken at different exposures to draw detail from areas which would traditionally have been over or underexposed. This effect is typically achieved using a Photoshop plugin, and HDRI images can contain significantly more information than can be rendered on screen or even perceived by the human eye.

HISTOGRAM

A map of the distribution of tones in an image, arranged as a graph. The horizontal axis goes from the darkest tones to the lightest, while the vertical axis shows the number of pixels in that range.

HSB (HUE, SATURATION, BRIGHTNESS)

The three dimensions of color, and the standard color model, used to adjust color in many image-editing applications.

HUE

The pure color defined by position on the color spectrum; what is generally meant by "color" in lay terms.

INTERPOLATION

The addition or deletion of pixels when Photoshop resizes an image.

ISO

An international standard rating for film speed, with the film getting faster as the rating increases. ISO 400 film is twice as fast as ISO 200, and will produce a correct exposure with less light and/or a shorter exposure. However, higher-speed film tends to produce more grain in the exposure, too.

JPEG (JOINT PHOTOGRAPHIC EXPERTS GROUP)

Pronounced "jay-peg," a system for compressing images, developed as an photographic industry standard by the International Standards Organization.

LAYER

In image editing, one level of an image file separate from the rest, allowing different elements to be edited separately.

LUMENS

A measure of the light emitted by a light source, derived from candela.

LUMINOSITY

The brightness of a color, independent of the hue or saturation.

LUX

A scale for measuring illumination, derived from lumens. It is defined as one lumen per square meter, or the amount of light falling from a light source of one candela one meter from the subject.

MASK

In image editing, a grayscale template that hides part of an image. One of the most important tools in editing an image, it is used to limit changes to a particular area or protect part of an image from alteration.

MID-TONE

The parts of an image that are approximately average in tone, falling midway between the highlights and shadows.

MONOCHROME

Describes an image that uses shades of only one color.

NOISE

Random pattern of small spots on a digital image that are generally unwanted, caused by non-image-forming electrical signals.

PERIPHERAL

An additional hardware device connected to and operated by the computer, such as a drive or printer.

PIXEL (PICTURE ELEMENT)

The smallest units of a digital image, pixels are the square screen dots that make up a bitmapped picture. Each pixel carries a specific tone and color.

PLUGIN

In image-editing, software produced by a third party, intended to supplement a program's features or performance.

PPI (PIXELS PER INCH)

A measure of resolution for a bitmap image.

PROCESSOR

A silicon chip containing millions of microswitches, designed for performing specific functions in a computer or digital camera.

RAW FILES

A digital image format, known sometimes as the "digital negative," which preserves higher levels of color depth than traditional 8 bits per channel images. The image can then be adjusted in software—potentially by three stops—without loss of quality. The file also stores camera data including meter readings, aperture settings and more. In fact, each camera model creates its own kind of Raw file, though leading models are supported by software like Adobe Photoshop.

RESOLUTION

The level of detail in a digital image, measured in pixels (e.g. 1,024 by 768 pixels), or dots per inch (in a half-tone image, e.g. 1200 dpi).

RGB (RED, GREEN, BLUE)

The primary colors of the additive model, used in monitors and image-editing programs.

SATURATION

The purity of a color, going from the lightest tint to the deepest, most saturated tone.

SELECTION

In image editing, a part of an on-screen image that is chosen and defined by a border in preparation for manipulation or movement.

SHUTTER SPEED

The time the shutter (or electronic switch) leaves the CCD or film open to light during an exposure

SLR (SINGLE LENS REFLEX)

A camera that transmits the same image via a mirror to the film and viewfinder, ensuring that you get exactly what you see in terms of focus and composition.

SPLIT TONE

The addition of one or more tones to a monochrome image.

TIFF (TAGGED IMAGE FILE FORMAT)

A file format for bitmapped images. It supports CMYK, RGB, and grayscale files with alpha channels, and lab, indexed color, and it can use LZW lossless compression. It is now the most widely used standard for good-resolution digital photographic images.

WHITE BALANCE

A digital camera control used to balance exposure and color settings for artificial lighting types.

Index

Picture Credits